"To temperance! I'll drink to that."
—*Cogswell Society toast*

PROHIBITION IN WASHINGTON, D.C.

HOW DRY WE WEREN'T

To Rick Sincere —
With all my thanks for
your friendship. Cheers!

GARRETT PECK

Charleston London

THE
History
PRESS

Published by The History Press
Charleston, SC 29403
www.historypress.net

First published 2011

Manufactured in the United States

ISBN 978.1.60949.236.6

Library of Congress Cataloging-in-Publication Data

Peck, Garrett.
Prohibition in Washington, D.C. : how dry we weren't / Garrett Peck.
p. cm.
Includes bibliographical references and index.
ISBN 978-1-60949-236-6
1. Prohibition--Washington (D.C.)--History. 2. Drinking of alcoholic beverages--
Washington (D.C.)--History--20th century. 3. Washington (D.C.)--History--20th century. 4.
Washington (D.C.)--Social conditions--20th century 5. Historic sites--Washington (D.C.) 6.
Cocktails--Washington (D.C.) I. Title.
HV5090.D6P43 2011
363.4'109753--dc22
2011002399

CONTENTS

FOREWORD

W hen I first began bartending, it had never occurred to me that my job was once illegal and that bartenders like myself had been forced out of work. Of the 3,000 bartenders employed in Washington, D.C., before the Prohibition era, 1,800 of whom belonged to the bartender's union, none remained behind the stick when prohibition became the law. The great barmen of the time moved to other countries or took jobs doing anything else. These journeymen, who had plied their trade with enthusiasm and pride, were reduced to outlaws if they continued their practice.

On September 16, 1928, John J. Daly, writing for the *Washington Post*, put it more plainly:

> *There are—officially—no bartenders in America.*
> *There are no bars.*
> *All that remain are memories.*

Well, it turns out that this was only partly true. As Garrett Peck will tell you, Washington, D.C., never really went dry, as speakeasies were plentiful. Drinking never really ended either, but bartending as a craft did. Bartending was subsumed into the new fervor for drinking highballs and rotgut, while the great punches, fizzes and Rickeys of the past were nearly forgotten. The golden age of bartending was over. Amateur bartenders replaced the professionals, and many of the techniques, styles and recipes that emanated from an era of great creativity were lost. These were sad times for drinkers, indeed.

Fortunately, bartending has since recovered—some seventy years after—and even blossomed due to the efforts of pioneering individuals reclaiming recipes from old bartending manuals and using fresh juices

instead of syrups from a soda gun, inspiring a new generation of bartenders to take their profession seriously. It is a great time to be a bartender and, by proxy, a drinker. One bartender dubbed the present as the platinum era in bartending.

Of course, locally we have seen a renaissance, too. In 2007, the DC Craft Bartenders Guild was founded by ten of the city's top bartenders to promote the profession. Since then, the district has added a cadre of young, well-informed mixologists to its roster and become a world-class cocktail city, with some of the most renowned bars in the United States. This is not to say that great bartenders were not always in Washington, but now the city is awash with talent.

The stigma of a stiff drink has also given way to a celebration of the craft with the DC Craft Bartenders Guild's annual Repeal Day Ball. Every year since 2008, the seventy-fifth anniversary of the repeal of prohibition, the guild holds a black tie ball in celebration with toasts, dancing and, of course, great cocktails. The party has become a grand event and continues to grow with local bartenders, national bartending legends and hundreds of guests. It is truly inspiring to see the bartending renaissance in full bloom and to know that we have come so far from the days when the craft nearly came to an end.

Derek Brown
DC Craft Bartenders Guild
Columbia Room

PREFACE

The nation's capital has been a drinking city since its founding in 1791. Washingtonians have a culture for cocktails and happy hours. We network with a résumé in one hand and a beer in the other. We enjoy dining out and pairing good wine with good food. Drinking is a crucial part of how we socialize and entertain. Journalist Walter Liggett wrote in 1929: "From its very inception the nation's capital has been known as a hard-drinking city—doubtless because of the prevalence of politicians."

Not everyone agreed that this was a good thing. The temperance movement launched a culture war that demonized alcohol and succeeded in changing the U.S. Constitution in 1920 to make alcohol illegal. The country changed the Constitution back less than fourteen years later after the "noble experiment" of prohibition failed.

Washington was to be the model city for the dry cause. Temperance advocates were eager to demonstrate that dry law could work nationally, and they used the national capital as a proving ground. The problem was that Washingtonians didn't want to go dry—and never would go dry.

Prohibition came early to Washington. It started on November 1, 1917—more than two years before the nation officially went dry—and ended on March 1, 1934. This book deals with what actually happened in the nation's capital during the sixteen years and four months of prohibition in the city.

The book is an outgrowth from a voluntary tour that I lead called the Temperance Tour. I created this in May 2006 as I was researching my first book, *The Prohibition Hangover*. My friend Amy Saidman asked if I could put together a Prohibition-oriented excursion for the Close Up Foundation, a nonprofit that brings civics teachers to Washington for experiential learning. The day of the first tour coincided with the opening of the new Woodrow

Wilson Bridge over the Potomac River, which is part of the Beltway. The first car over the bridge was Wilson's 1923 Rolls Royce. Just as my tour arrived at the Woodrow Wilson House that afternoon, the car coincidentally drove up, carried on a flatbed truck. The teachers *ooohed* and *ahhhhed* over the car. That lovely Rolls Royce was on loan to the house for several years; however, once the car's owner died, the estate reclaimed it.

According to the 1920 U.S. Census, Washington, D.C., had 437,571 people. The population had ballooned by 100,000 people during World War I, causing housing shortages and interracial tension that exploded into a four-day race riot on the eve of prohibition. The city was far more densely packed than it is today—the suburbs didn't exist yet, and the automobile was just coming into vogue (the district had fifty-six thousand cars in 1920, but a decade later that number had tripled). The car made the bootlegger's job much easier in moving booze to market and providing a speedy getaway. Washington was a tightly compact city, one that you could walk across—from Capitol Hill to Georgetown, from the Washington Navy Yard to Mount Pleasant—in just a few hours. This density makes Prohibition-era Washington easy to explore.

Yet the city has changed much since the 1920s. The McMillan Plan envisioned a National Mall free of blight, and the shanties along it were cleared. The New

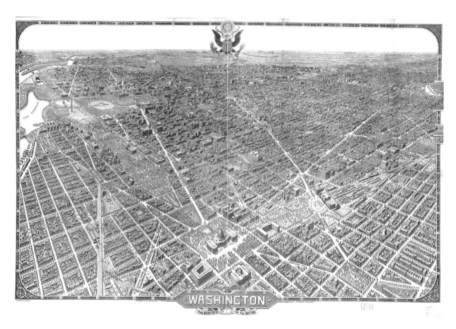

A panoramic image of Washington, D.C., in 1921. *Library of Congress, Geography and Map Division.*

Deal cleared out Hooker's Division, replacing it with the government buildings of the Federal Triangle. K Street, the heart of downtown, was once residential, but now it's almost entirely occupied by mid-rise commercial buildings. The 1950s brought "urban renewal" that built new federal properties in Southwest, largely at the expense of African Americans. And gentrification has altered the city's demographics as wealthier people displaced the poor.

Even today, Washington is a southern city. Its climate is hot and humid in summer, and the city gets spectacular thunderstorms. Many houses have porches on them. It is still provincial enough that you can drive and park almost anywhere—unlike, say, New York City or Philadelphia, whose streets are narrow and crowded. And above all, Washington was segregated until the 1950s. This is a city whose grandest early public buildings—the White House and the U.S. Capitol—were built by slaves.

Politics were at the center of prohibition. Five presidents occupied the White House during the nearly fourteen years of national prohibition: Woodrow Wilson, Warren Harding, Calvin Coolidge, Herbert Hoover and Franklin Delano Roosevelt. Republicans controlled Congress during most of this era, but Democrats seized both houses in 1930 as the Great Depression set in. The Depression sealed prohibition's fate, and the country ordered the noble experiment ended.

This book is intended as both a history and a guidebook for exploring prohibition in Washington, D.C. No one has ever attempted such a story. I have relied almost entirely on primary sources. Besides a plethora of contemporary newspaper articles, there were numerous commentators who provided fodder: H.L. Mencken, Rufus Lusk, Raymond Clapper, Walter Davenport, Kelly Miller and Walter Liggett, as well as George Cassiday's tell-all series about bootlegging for Congress in the *Washington Post*—not to mention the personal memoirs or journals of people like Mabel Willebrandt, Herbert Hoover, Edith Wilson, Christian Heurich and Larz Anderson. All of these people lived through the Prohibition era and had strong opinions about it.

This is the story of how prohibition unraveled in the nation's capital—and how impossible it was to impose dry law on an unwilling population. Washington in the Jazz Age proved to be anything but a model dry city.

I extend heartfelt and numerous thanks to so many people who were instrumental in this book, like John Powell, Sarah Andrews and the docents of the Woodrow Wilson House, who were exceptionally generous with their time and knowledge. Fred Cassiday, son of bootlegger George Cassiday, and his wife, Karen, opened their family history to me. Local historian Cindy Janke explained D.C.'s lost brewing culture. Elizabeth Frengel of the Society

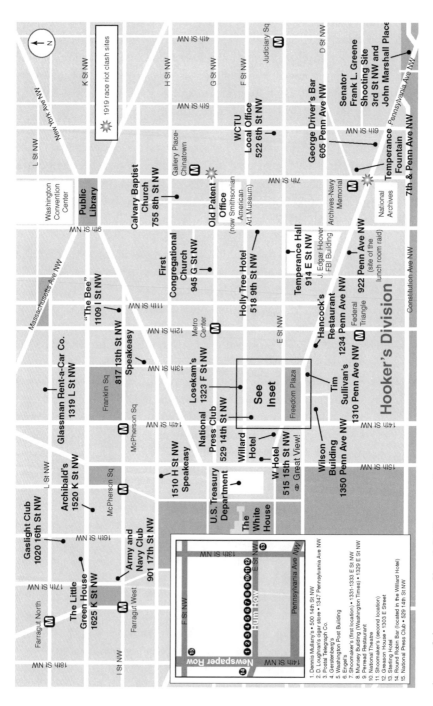

A map of downtown. Kenneth P. Allen, mapmaker.

of the Cincinnati provided Larz Anderson's personal journals. Scott Nelson, executive director of the Heurich House Museum, provided great insight into Christian Heurich and led a fab tour. I give thanks to Jimmy Didden of National Capital Bank for his generous information of the Carry-Didden families and to Rayner Johnson and the other D.C. Collectors members who generously shared their brewery memorabilia ("breweriana") collections. Rufus Lusk III filled me in on his crusading grandfather.

Kenny Allen created brilliant neighborhood maps that are instrumental to exploring Prohibition-era Washington. Derek Brown, ambassador of the DC Craft Bartenders Guild, penned the foreword and shared his copy of Charles Wheeler's manuscript. And thanks to all of the bartenders who have made Washington a far better place to enjoy a cocktail. Speaking of cocktails, bartenders Phoebe Esmon and Christian Gaal reinvented the Flower Pot Punch—a lost cocktail from before the Prohibition era. Thanks also to the many friends who reviewed and critiqued chapters. The archivists at the Historical Society of Washington, D.C., and the D.C. Public Library were instrumental in locating primary material. John DeFerrari generously provided the 1908 postcard of Rum Row, and Brock Thompson helped me locate historic images at the Library of Congress. Thanks to Hannah Cassilly and Marjorie Comer at The History Press for putting up with me! Lastly, thanks to Jim Webb for a fun author photo, taken at the Repeal Day Ball 2010.

ℐEMPERANCE!

Quite possibly the ugliest statue in all of Washington, D.C., is the Temperance Fountain, erected in 1882 by California dentist Henry Cogswell. Two intertwined dolphins once spewed water from their mouths. A large crane rests on top. At the base, covered by metal grates, is a well that the city filled with ice. There once was a metal cup that allowed passersby to get a drink of water. Eventually the city tired of filling the fountain, and the water was turned off. At one point, a wire hanger—the kind you get at the dry cleaners—hung from the bird. People have long forgotten the meaning of the statue. They wanted to forget temperance, as temperance gave us prohibition. And prohibition didn't turn out so well.

Cogswell made his fortune in the California gold rush and lived in San Francisco. He funded dozens of these temperance statues nationwide, but only a handful survive. There is nearly an identical fountain in New York's Tompkins Square Park in the Lower East Side, which was once a German neighborhood known as *Kleindeutschland* (Little Germany). You wonder how successful such heavy-handed moralizing was to a community that made beer into America's favorite alcoholic beverage.

Washington's Temperance Fountain was initially located at the corner of Seventh Street and Pennsylvania Avenue, but it traded places with the monument to the Grand Army of the Republic when the city created Indiana Plaza. Ironically, for years the statue stood in front of the Apex Liquor Store.

The location of the fountain is quite significant: it is halfway between the White House and the U.S. Capitol along Pennsylvania Avenue. It is located directly across from the National Archives, which was established in 1931 on the site that housed Center Market. And adjacent to the market was Hooker's Division, Washington's red-light district. This was a very poor neighborhood

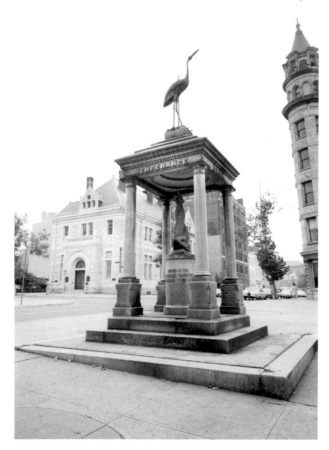

Built in 1882 opposite Washington's red-light district, the Temperance Fountain symbolically told people to drink water, not whiskey. Henry Cogswell financed dozens of these fountains nationwide. *Historic American Buildings Survey, Library of Congress.*

of shanties and tenements, a den of brothels, gambling parlors and saloons. The division ran from Tenth Street to Fifteenth Street, Northwest—roughly where the Ronald Reagan Building and Department of Commerce are now. *Washington Post* columnist and historian George Rothwell Brown called Hooker's Division "the city's most evil eyesore." Cogswell's message was clear to all who passed by: drink water, not whiskey.

Four words are inscribed around the Temperance Fountain's canopy: FAITH, HOPE, CHARITY and TEMPERANCE. The first three words come right out the Bible from 1 Corinthians 13, which was St. Paul's famous letter on the nature of love: "And now these three remain: faith, hope and charity. But the greatest of these is charity." Later English versions of the Bible translate charity as love. The word "temperance" wasn't part of Paul's letter, so why is it on the fountain? The answer is that the temperance movement was tying the Bible to its cause, which was to keep the nation from drinking alcohol.

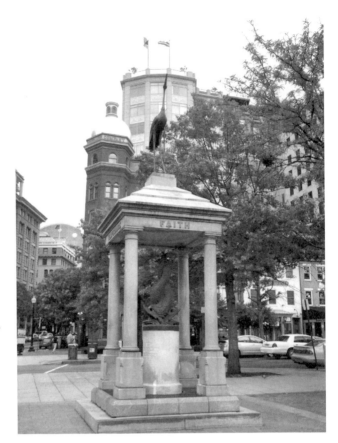

During the rehabilitation of Pennsylvania Avenue, the Temperance Fountain switched places with the Grand Army of the Republic monument. The Temperance Tour begins here. *Garrett Peck.*

Henry Cogswell and temperance have largely been forgotten—some in Congress wanted to tear down the fountain—but a group exists to celebrate the fountain's ugliness: the Cogswell Society. It was established in 1972 when several members of the Federal Trade Commission began meeting for lunch and telling jokes. The members wear ribbons around their necks, at the bottom of which is a wire hanger, symbolizing the clothes hanger that hung from the crane for years—and in jest reminding people how irrelevant the temperance cause had become. I was invited to speak at one of the society's lunches. When the host raised his glass "To temperance!" all responded in unison, "I'll drink to that!"

Temperance didn't rise out of a vacuum but was instead a response to a nationwide whiskey-drinking binge in the early nineteenth century. Whiskey was cheap in the early American republic. When people settled in the Ohio River Valley—in Kentucky, Ohio and Tennessee—they grew far too much

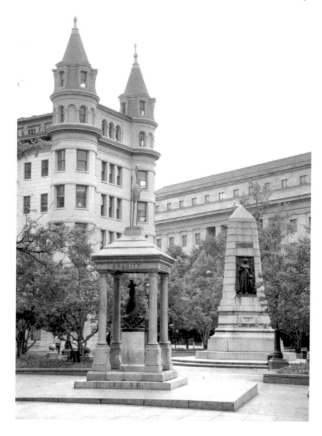

A stately view of Indiana Plaza, home to the Temperance Fountain (center) and the Grand Army of the Republic monument (right). This is located halfway between the White House and the U.S. Capitol. *Garrett Peck.*

corn, but there were few roads to get their crops to market. Instead, they distilled their excess corn into whiskey, which weighed a lot less than an entire crop of corn and could command many times the price.

There were virtually no taxes on whiskey. After the Whiskey Rebellion of 1794, Congress eventually repealed the whiskey taxes. By the 1820s, the nation was on a huge whiskey-drinking binge, the likes of which we haven't seen before or since. Men were doing most of the heavy drinking, as they took to saloons for cheap booze. A classic study on the whiskey binge and the origins of the temperance movement—published in 1979 by W.J. Rorabaugh and known as *The Alcoholic Republic*—estimated that the binge peaked in 1830. That year, Americans drank 5.2 gallons of ethanol per person (and 7.1 gallons per man when women and children are excluded). This was more than double what Americans drink today.

So what was "temperance?" Temperance was a nineteenth-century social reform movement that believed that banning alcohol would improve

American society, reduce crime and poverty and make everyone more respectably middle class. The temperance movement lasted for more than a century and culminated in the Prohibition era.

The movement was thoroughly Protestant and evangelical. In fact, we may call it one of the country's first faith-based initiatives. It began with a few congregational leaders in New York and Massachusetts and picked up steam during the Second Great Awakening of the 1830s. The Methodist Episcopalian Church became the first church to embrace temperance as part of its official doctrine in 1830. Many American-born churches, such as the Mormon Church, the Seventh Day Adventists and the Christian Scientists, originated during this time—and they all embraced temperance as part of their doctrine.

The movement spread to the Midwest and into the Deep South by the end of the century. It was particularly influential in rural areas; it had a much harder time in cities, where people tended to socialize in saloons. Catholic immigrants from Germany, Ireland, Italy and Poland, as well as Jews from eastern Europe, tended to settle in cities and brought their drinking habits with them. These groups had no theological issues with drinking. The temperance movement heaped scorn on Catholics, as they didn't represent their ideal of a dry, Protestant America.

When you think of the word "temperance," you might think moderation—and that's what the first leaders meant as they tried to get

The temperance movement declared a culture war against alcohol and demonized drinking as a tool of the devil. It culminated with national prohibition (1920–33). *Prints and Photographs Division, Library of Congress.*

people to drink beer and wine instead of distilled spirits. They didn't mean outright abstinence. But more radical people had seized control of the movement by the late 1820s, and they pushed abstinence.

Temperance was the *other* kind of abstinence—not merely drinking in moderation, but completely refraining from it instead. Being a teetotaler was virtuous, while a drinker (or a "drunkard") was someone with loose morals. To them there was no such thing as moderation—anyone who drank alcohol was on the slippery slope to alcoholism. A drunkard spent his wages on whiskey, leaving his family destitute. To those in the temperance movement, alcohol was the root of evil, and it had to be purged from society. Showing its religious roots, it even had a handy name for alcohol: Demon Rum.

Protestant preachers saw all of the hard-core whiskey drinking and couldn't fathom that Jesus would have ever drank, so they developed a theory that the Jews drank unfermented wine. That was not archaeologically, biblically, historically or scientifically accurate, and it showed no understanding of the central role of wine in Judaism. Wine is mentioned in every chapter of the Bible except for the book of Jonah. Yet temperance advocates had no way of making unfermented wine. They took it on faith that Jesus was a teetotaler like them.

And then, as they say, a miracle happened.

In the 1860s, many French wines were mysteriously going bad. The French government asked scientist Louis Pasteur to investigate. Pasteur figured out how fermentation actually works by watching the process under a microscope. He observed that natural enzymes on the skins of grapes come into contact with the grape's sugar when it is crushed. The enzymes consume the sugar, and the byproduct is alcohol. But Pasteur also discovered that bacteria were getting in the wine, which was spoiling the product. To counter this, he invented a process to flash-heat the wine to kill the bacteria without damaging the wine. Pasteurization was born. This is what we use to keep milk from spoiling.

There was a temperance-minded dentist named Dr. Thomas Bramwell Welch, who was a communion steward at the Vineland Methodist Church in New Jersey. He wanted to give his congregation an alternative to wine. He read up on Pasteur's research and figured that he could use flash heating to stop fermentation. In 1869, he successfully pasteurized Concord grape juice, giving birth to Welch's Grape Juice, a staple for Protestant communion services ever since. The Methodists officially required all of their churches to start using "unfermented wine at the Lord's table" in 1880, and it's been that way ever since.

How Dry We Weren't

The Temperance Fountain may be the last remnant of the movement in Washington, but there was once a thriving temperance business scene. Temperance advocates operated their own hotel. The Holly Tree Hotel and Dining Rooms was located at 518 Ninth Street, Northwest. Visitors to the nation's capital could be assured of fine food and no alcohol on the premises. (The site was later torn down; there is an office building now.) Just around the corner, on E Street, was Temperance Hall (914 E Street), built in 1843 by the Freeman's Total Abstinence Society. It was razed in 1935; eventually the spot became the site of the J. Edgar Hoover FBI Building.

For the first half of the 1800s, the temperance movement was overshadowed by the national issue of slavery. But after the Civil War, a new generation of temperance leaders pushed forward—Henry Cogswell was one member. It all began with an impromptu grass-roots protest. Inspired by a temperance lecture, a group of woman in Hillsboro, Ohio, decided one winter day in 1873 to picket a saloon with hymns and prayers. They were tired of their husbands' philandering ways. This tactic proved

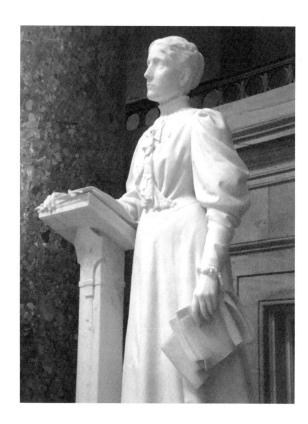

Frances Willard was the president of the WCTU for two decades and one of the most influential American women of the nineteenth century. She was the first woman to have a statue erected in her honor in the U.S. Capitol. *Garrett Peck.*

so successful that most of the town's saloons closed down in less than two weeks. The women were immortalized as "crusaders."

Just a year later, the Woman's Christian Temperance Union was founded in 1874 in Cleveland, Ohio. It was led by Frances Willard, who was the first woman to have a statue erected in Statuary Hall in the U.S. Capitol. Today we'd call the WCTU an issue advocacy group. WCTU members pledged to raise their families in alcohol-free homes. Probably the best-known member of the WCTU was Carrie Nation, who embarrassed the group by taking an axe to demolish illegal saloons around the country.

As women couldn't vote yet, the WCTU focused on education and moral suasion. They would warn children in the classroom about the dangers of alcohol. They held a quack experiment for the children: a WCTU representative would pour alcohol directly onto the brain of a dead cow or sheep, immediately turning it gray. The experiment had no scientific merit, but that was beside the point, which was to frighten children so they

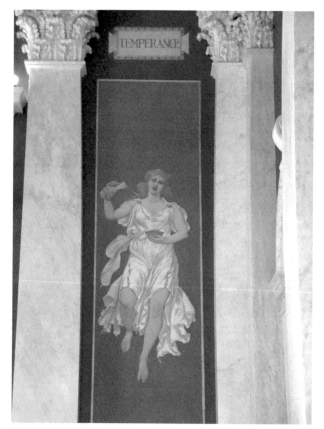

The Great Hall of the Library of Congress includes an allegorical fresco, where the spirit of temperance pours water into a drinking bowl. In the ancient world it undoubtedly would have been wine. *Garrett Peck.*

wouldn't touch alcohol. Generations of children grew up feeling guilty about ever touching alcohol, so strong had the stigma become. The WCTU's local office was at 522 Sixth Street, Northwest.

The temperance movement was closely tied in with other Christian social issues. We date many of our blue laws from this period—for example, laws that required businesses to close on Sundays, as people were supposed to be in church and not shopping. Even the ice cream sundae was named so as not to offend Sabbatarians. The WCTU successfully lobbied to close Washington saloons on Sundays.

The women's suffrage movement was also growing at this time but didn't have nearly the support—or the membership—as the WCTU. Elizabeth Cady Stanton and Susan B. Anthony realized that they had to tie suffrage to temperance if they ever wanted to succeed in getting the vote. The efforts of these two movements—suffrage and temperance—would ultimately culminate in two Constitutional amendments that went into effect in 1920. It was no coincidence that women got the vote and alcohol was outlawed in the same year. However, the alliance between women and temperance broke apart once women had the vote and decided that they had earned a place at the speakeasy.

Rum Row

Henry Cogswell picked a strategic spot for his Temperance Fountain at the corner of Pennsylvania Avenue. The "Avenue," as locals simply called it, was the main thoroughfare of the time. Many bars, hotels, restaurants and theaters were located along the way.

Raymond Clapper described Pennsylvania Avenue for the *American Mercury* in 1927: "It was an Appian Way of Bacchus, with forty-seven bars to its mile. Probably nowhere in America were there such superb drinking facilities in equally compact form." At Fourteenth Street, Northwest, the Avenue converges with E Street, better known as Rum Row.

"Almost from the earliest days old E Street was the center of Washington's sporting life, and particularly its night life," wrote George Rothwell Brown in his 1930 history of the district. It grew up organically: congressmen needed a place to reside during their months in Washington, so hotels like the Willard and the Old Ebbitt House (now the Old Ebbitt Grill) sprung up. These men also needed a place to drink, gamble and socialize, so saloons sprung up in the area—especially Rum Row. Happy hour started every day at noon with a free lunch in most bars.

A 1908 postcard of Rum Row, home of Washington's finest drinking establishments. *John DeFerrari.*

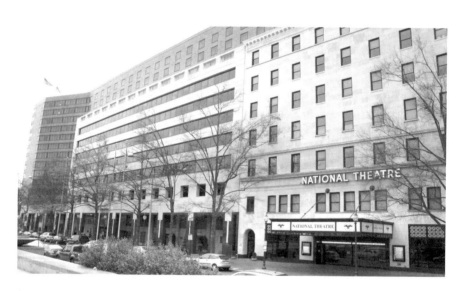

Rum Row was Washington's premier drinking area, stretching along E Street from the National Theatre to the corner of Fourteenth Street, Northwest, now occupied by the J.W. Marriott Hotel. *Garrett Peck.*

Rum Row lay along the north side of E Street, just east of Fourteenth Street and directly across from the District Building. It was quite a colorful part of town—a series of saloons where journalists, lobbyists and politicians rubbed shoulders. Among the bars and restaurants were Dennis Mullany's, Greason's, Gerstenberg's, Engel's (the Washington Post Building sat between the latter two, and the Munsey Building, home to the *Washington Times*, was also on the block), the French restaurant Perread and Shoomaker's (1331–33 E Street).

Just across Fourteenth Street to the west, the fabulous Willard Hotel had quite the reputation as a quality drinking establishment—and still does with the Round Robin Bar. Around the corner was Losekam's restaurant (1323 F Street), where critic H.L. Mencken liked to sip ale when he was in town. Down the street, at 1234 Pennsylvania Avenue, was Hancock's, one of the best-known restaurants in the city, as well as Tim Sullivan's. Famed bartender Henry Thomas worked at George Driver's Bar (605 Pennsylvania Avenue) for fourteen years; he also put in time at Shoomaker's, the Willard and at a number of other bars. Thomas ended up working at the Chevy Chase Country Club during the Prohibition era.

Shoomaker's was one of the more notable hangouts in Washington. Two German immigrants, Otto Hertzog and William Shoomaker (the latter's name was Anglicized), came to the United States in the 1850s and fought as Union officers in the Civil War. They founded Hertzog and Shoomaker's at 1331 E Street in 1858. They not only sold cocktails but were also importers who sold retail to the public. Most people just called it "Shoo's."

In truth, Shoomaker's was a bit of a dive. Raymond Clapper wrote, "There was no more disreputable looking bar in town. Dilapidated is a better word." Some called it "Cobweb Hall," but the drinks were famously tasty, and the clientele was equally prestigious.

Colonel Joseph Rickey, a Democratic lobbyist from Missouri, bought Shoomaker's in 1883 after the two owners died and owned the bar until his own death in 1903. Bartender George Williamson invented the Rickey there in the 1880s, naming it after his boss. The Rickey is Washington's claim to cocktail fame, nicknamed "air conditioning in a glass." Shoomaker's moved to 1311 E Street in 1914 after fifty-six years at its first location.

Newspaper reporters would join congressmen along Rum Row to drink, especially at Dennis Mullany's. It was no surprise then that Newspaper Row developed just around the corner on Fourteenth Street. Stretching north along the block between E and F Streets were the local bureaus of more than thirty national newspapers, like the *New York Times*, the *Boston Transcript*, the *Cincinnati Commercial* and the *Philadelphia Public Ledger*. The concentration

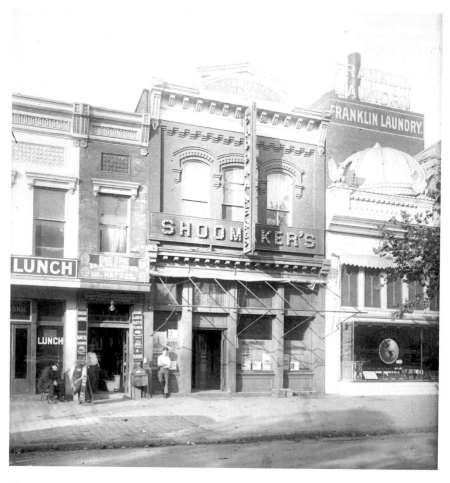

Shoomaker's was Washington's most famous saloon. The Rickey was invented there in the 1880s. This photo from 1916 or 1917 shows Shoomaker's at its second Rum Row location. *Prints and Photographs Division, Library of Congress.*

of press bureaus earned the street its nickname. The 1893 Washington Post Building was located on Rum Row itself at 1337 E Street.

Prohibition shut down the saloons, and over time the newspapers closed their Washington bureaus. The bartenders found other careers, and some even moved to Europe to continue mixing cocktails, but the Prohibition era destroyed the art that they had developed for mixing drinks. The only reminders of the Rum Row/Newspaper Row glory days are the National Press Club Building and the National Theatre. Historian George Rothwell Brown noted poignantly: "Twins cannot thrive when separated."

PROHIBITION COMES EARLY

With its bright red brick exterior and steeple, Calvary Baptist Church (755 Eighth Street, Northwest) stands in the heart of Washington's small Chinese community. The Chinese were resettled in this neighborhood in the 1930s when the federal government acquired the land that is now the Federal Triangle across from the Temperance Fountain. The Friendship Arch, which stretches all the way across H Street, was built in 1986. Many restaurants and street signs in Chinatown have Chinese characters; in truth, there are few Chinese people left in the neighborhood.

Calvary Baptist Church is an unusual building in a city known for its marble public buildings. Its red brick was a signature feature of architect Adolf Cluss. An immigrant from Germany, Cluss was known as the "Red Architect," as he was a friend of Karl Marx and also designed public buildings with red, polychrome brick. Most of the buildings in the district that he designed have been torn down, but a few prominent buildings still stand: Eastern Market on Capitol Hill, the Sumner and Franklin Schools downtown and the Great Hall at the Patent Office. His masterpiece is the Arts and Industries Building on the National Mall, right next to the Smithsonian Castle.

Calvary Baptist was first built in 1862 during the Civil War but then burned down in 1866. The congregation hired Cluss to rebuild the church. This was the edge of the city at the time, and beyond it was farmland. Washington only had fifty thousand people—less than a tenth of the city's population today.

When the nearby MCI Center (now the Verizon Center) opened in 1997, property values in Chinatown soared. Calvary Baptist sold its vacant lot and the air rights over its office building for $12 million. This paid for the

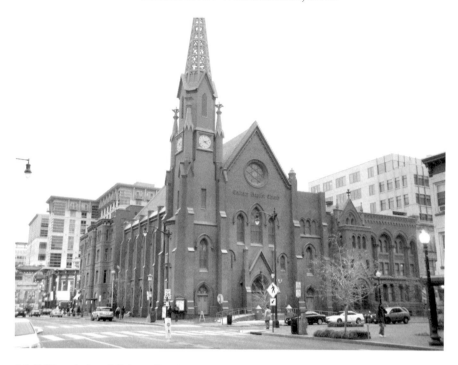

Adolf Cluss designed Calvary Baptist Church in 1866. The Anti-Saloon League held its first national convention in the building in 1895. Today the church is a thriving urban congregation in Chinatown. *Garrett Peck.*

renovation of the church. The iron spire atop the church toppled over in 1913, and the crown was later struck by lightning, but a new alloy-based spire was installed in February 2005.

So what is Calvary Baptist Church's significance to the temperance movement? The reason is that the Anti-Saloon League, or ASL, held its first national meeting there on December 18, 1895. This was the group that ultimately gave the nation prohibition.

The Anti-Saloon League

Congregational minister Howard Russell formed the Anti-Saloon League in Ohio in 1893, two years before the convention at Calvary Baptist Church. Russell had the foresight to hire a bright young Oberlin College student, Wayne Wheeler. Wheeler has almost been completely forgotten to Americans. This man, more than any other, gave us prohibition.

There has never been an advocacy group quite like the Anti-Saloon League in American history, nor one as powerful. Not even the National Rifle Association is as powerful today as the ASL was in its heyday. The ASL was tightly focused on a single issue: banning the "liquor traffic." It reached across party lines, gaining both Republican and Democratic support for its cause. And it was eminently pragmatic: it supported candidates who voted dry—even if they were wet in their personal lives. Wheeler invented the term "pressure group." It was he who crafted the ASL's tactics of squeezing politicians into voting dry.

So why was the Anti-Saloon League against the saloons? The answer is that the breweries and distilleries owned most of the saloons in the country. Closing them would starve the beast. It was a way of cutting off the supply of alcohol. However, the temperance movement never looked at the demand side of the equation—why do people want to drink?

The ASL moved its headquarters out of Washington in 1909 and relocated to Westerville, Ohio, a suburb of Columbus. However, it maintained a local office in the Bliss Building (35 B Street, Northwest, now Constitution Avenue), directly across from the U.S. Capitol. The building was owned by Alonzo Bliss, who among his other ventures trafficked in medicinal marijuana and herbal remedies. He had a chain of stores along the East Coast. The Bliss Building was later torn down and is now the location of the Robert A. Taft Memorial.

Congress governed the District of Columbia, and it first brought dry law to the city on July 1, 1913, through the ASL-influenced Jones-Works Excise Bill. It put heavy restrictions on saloons; besides increasing license fees, it required at least four hundred feet between saloons and schools or churches and, above all, reduced the number of saloons from about 525 to 300 by late 1914. Saloons won a few concessions, such as the rights to stay open until 1:00 a.m. and open on Sundays. This upset Sabbatarians, who wanted no alcohol sold on Sundays. They would get their wish for Sunday closings—as well as Monday through Saturday—in short order.

The ASL's ultimate goal was to change the Constitution to ban alcohol. It's not easy to change the Constitution: two-thirds of Congress must approve a constitutional amendment, and three-quarters of the states have to ratify it. In the early twentieth century, that meant thirty-six states (the country had forty-eight states at the time). The Founding Fathers put this high hurdle in place to ensure that we don't tinker needlessly with the Constitution. The ASL had its work cut out.

Under Wheeler's tireless efforts, the ASL adopted a ground-up strategy of going after the states. He leveraged his base, the evangelical Protestant ministers across the Midwest and South who could put mighty pressure on

politicians. "Never again will any political party ignore the protests of the church and the moral forces of the state," Wheeler wrote. The ASL's allies first pressured the states to adopt "local option laws." This allowed counties and towns to declare themselves dry—something we still see widely across the South and Midwest today.

With local option laws in place, the state was pressured to adopt statewide prohibition. Once the states were dry, the congressmen and senators would have to vote dry, no matter if they were personally wet. By 1915, the majority of states had some form of prohibition law on the books, so the idea of nationwide prohibition wasn't so far-fetched.

After leading the charge to make the majority of states dry, Wheeler moved to Washington in 1916 as the ASL's legislative superintendent and general counsel. His was job was convince Congress to change the Constitution to ban alcohol. Historian Daniel Okrent summarized, "It happened, to a large degree, because Wayne Wheeler made it happen."

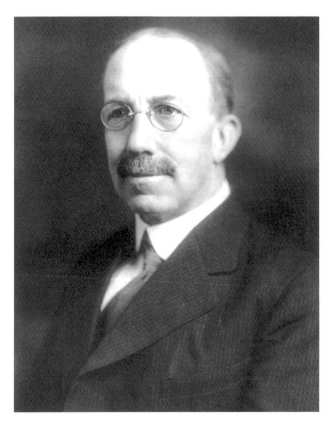

Wayne Wheeler was the legislative superintendent of the Anti-Saloon League. He moved to Washington, D.C., in 1916 to push the Eighteenth Amendment through Congress. *Prints and Photographs Division, Library of Congress.*

How Dry We Weren't

And then a worldwide calamity broke out that gave the ASL its opportunity: World War I. The United States declared war against Germany in April 1917. A wave of anti-German hysteria overtook the country, fomented in part by the ASL. German Americans, who represented the largest ethnic group in the nation, found themselves branded as traitors. They controlled the brewing industry, and beer drinking was now viewed as unpatriotic. Whether it was true or not, the ASL made political hay of an alleged attempt by the German-dominated United States Brewers Association to buy the *Washington Times* as a mouthpiece. To further demonstrate their patriotism, Americans changed the names of many food items. Frankfurters became hot dogs. German toast became French toast. Sauerkraut became liberty cabbage, though that name didn't stick.

Having marginalized the Germans and much of the opposition, the ASL seized its opportunity: it proposed amending the Constitution to outlaw the liquor traffic. The country needed this for the war effort. Why was the nation brewing beer when our soldiers needed bread, the ASL asked? The ASL had proposed the amendment once before in 1914, but the amendment didn't get the necessary two-thirds of Congress to support it. This time, however, World War I was on, and the Eighteenth Amendment sailed through Congress with little debate in 1917 (the Senate ratified the amendment on August 1, and the House on December 18). Then it cleared through the states by January 1919. Of all forty-eight states, only two didn't ratify the amendment: Connecticut and Rhode Island, both of which had significant populations of Catholics who opposed prohibition.

National prohibition went into effect January 16, 1920. It did not make alcohol illegal—rather, it made the *manufacture, transportation* and *sale* of alcohol illegal. You could still possess it, and people could still make homemade beer or wine. However, the temperance movement assumed that people would simply drink up what they had at home, and once their house was dry, they wouldn't drink anymore. We might find that a little naïve today, but this was what they thought. Americans are law-abiding people; when laws are established, Americans obey them, right?

Daniel Okrent in his book *Last Call* pointed out how differing constituencies came together to support prohibition in an "unspoken coalition: racists, progressives, suffragists, populists (whose ranks also included a small socialist auxiliary), and nativists." All had their reasons for wanting to ban Demon Rum. This was part of the Progressive Era—and indeed temperance was a progressive movement. Its goal was the sobriety and improvement of American society. It defined what it meant to be a respectable American—a

way of saying, "This is America, and we don't drink here." This sentiment was targeted at the immigrant populations, particularly Catholics.

The same year that prohibition became the law of the land, the Nineteenth Amendment went into effect, giving women the right to vote. Temperance and suffrage were tied at the hip for decades, but now that each got what it wanted, the two movements went their separate ways. As we'll see, women who had lined up to vote weren't necessarily the same people who would decline a drink.

One thing must be said about the social forces behind prohibition. Prohibition was the last hurrah for a declining white Protestant rural America. It was their attempt to impose social values on an increasingly urban country. And the seeds of prohibition's failure were sown at the beginning. There was no real national consensus around prohibition. The Eighteenth Amendment was passed under a false pretense, leveraging the crisis of World War I and assuming a consensus when there wasn't one. Americans changed the Constitution because of the political power of a small pressure group, the ASL. Large parts of American society were not behind the dry law and, in fact, worked actively to undermine it.

Those parts of society that failed to observe the dry law were concentrated in cities. When researching my first book, *The Prohibition Hangover*, I contacted the Economic Research Service of the U.S. Department of Agriculture to ask about the ratio of Americans who farmed. The man who responded was legendary demographer Calvin Beale (he died in 2008 at age eighty-five, still an ERS employee). His response showed how much urbanization changed America. In 1920, the first year of the Prohibition era, 27 percent of Americans farmed. Fast-forward eighty years to the 2000 U.S. Census, which counted less than 2 percent of the country's population raising all of the food to feed the other 98 percent of us. Americans became an urban and suburban people as they moved to cities for better-paying jobs. It was this shift to the melting pot cities that helped undermine temperance.

The Anti-Saloon League understood that the demographics of the country were decisively changing from rural to urban, a trend that did not bode well for the dry crusade. As a result, it forestalled Congressional redistricting after the 1920 Census. This was in violation of the Constitution, which requires redistricting. Doing so gave the ASL's rural base extra power during the following decade. Congress finally allowed redistricting in 1929, though the new districts would only go into effect for the 1932 election. As it turned out, this gave wet Democrats an even greater lead in Congress just as Franklin Delano Roosevelt entered the White House.

Prohibition Begins in Washington, D.C.

When the United States declared war on Germany in April 1917, the Anti-Saloon League began making its case that the country should close the breweries and distilleries to conserve grain for the war effort. Wayne Wheeler had moved to Washington the year before as the ASL's legislative superintendent, and he had a splendid idea: Congress should declare the nation's capital dry. The district is not a state—it says so in the Constitution—so Congress governed the city from its establishment in 1791 until home rule in 1973. Thus it was Congress's right to impose dry law on the city.

Wheeler marshaled his allies. Chief among them was Texas senator Morris Sheppard. Yale-educated and Shakespeare-quoting, Sheppard was one of the leading progressives in Congress, a man committed to the dry cause. He authored the Eighteenth Amendment (prohibition) and fiercely defended it, literally, until the end. Sheppard also sponsored the Sheppard Act, which inaugurated the Prohibition era in the nation's capital on November 1, 1917.

There was no referendum on the Sheppard Act—Congress simply declared that its fiefdom would now be dry. The local business community united against the law, knowing how much this would negatively affect the economy. In early 1917, the *Washington Times* estimated that the district would lose up to 2,500 jobs and $500,000 annually through prohibition. At the time, there were 267 barrooms in the district (the Jones-Works Excise Bill allowed for up to 300 to exist). There were also four breweries within the city.

President Woodrow Wilson seemed in favor of home rule and local licensing of alcohol; however, he signed the Sheppard Act on March 3, 1917. He understood that it was Congress's constitutional right to govern the district, and he recognized that the wet tide was receding. He bowed to political reality. He also had a much larger issue to deal with: he was preparing the nation for war. The United States declared war on Germany the following month.

A last-ditch effort by saloon owners sought an injunction against the Sheppard Act, but the district court ruled it constitutional. Halloween would mark the last hurrah for booze in Washington. The *Washington Times* headline on October 31, 1917, read: "Devotees of Bacchus Will Bid Booze Farewell Tonight as Goblins Stalk." Throughout the day, bars and wholesalers auctioned off their remaining stocks and even the barware. Most saloons drew down their supply and had simply closed by 10:00 p.m. A few held on until midnight as loyal customers got one more drink in. Ever defiant, Shoomaker's held out to the end. "Shoomaker's will keep open until midnight tonight and will open tomorrow as a soft drink establishment," the

Times noted. Major Raymond Pullman, the chief of police, dispatched a gauntlet of police to protect the area, but there was very little disorder. The paper concluded: "The entire family of drinkers will be at the bedside of J. Barleycorn tonight when the demise comes. There will be no opportunity for a wake."

Prohibition threw much vacant commercial and retail space on the market; however, with World War I underway and the local economy booming, properties were quickly absorbed. Most of the unemployed bartenders and beer bottlers found work elsewhere soon (the Bartenders Union numbered 1,800 people). But in that time of racial segregation, African American workers had a more difficult time finding new employment. Reverend Simon P.W. Drew of the Cosmopolitan Baptist Church in Shaw (1001 N Street, Northwest) noted the effect on many congregants in his black church: "When the saloons of the city close tomorrow, it will throw 900 negroes out of a job." Most of them worked as porters.

Senator Sheppard released a statement extolling dry law in Washington: "The white banner of prohibition will then float from the dome of the Capitol of the United States, never to come down." He promised that the dry law would mean far less crime—in fact, "Crime will decrease to the vanishing point. The police courts will find their business trail off remarkably. Families will be happier, and businesses will be better off as men spend their money on other things besides alcohol." He noted that this was a precursor to national prohibition.

Now let's be clear. Despite Senator Sheppard's assurances, *Washington never actually became dry*. The liquor still flowed, illegally, and Congress itself remained wet. But that didn't help the brewers, the hundreds of saloon owners or the thousands of bartenders who were suddenly out of business.

All of the saloons along Rum Row were closed in 1917 and later razed to make room for the J.W. Marriott Hotel. Shoomaker's didn't last long as a soft drink retailer. By March 1918, the joint had closed after discovering that soft drinks weren't profitable. The final few patrons and management stripped the place for souvenirs, and then "Shoo's" was no more.

The Sheppard Act had closed the saloons and made the district a dry domain, but it was not "bone dry." People could still bring alcohol into the city for their personal use. The district's revenue bill for 1919 included a bone dry stipulation, and President Wilson signed it. As of February 25, 1919, all alcohol in Washington became illegal save for that prescribed by a doctor. No alcoholic beverages were allowed for personal use. The dry cause was uncompromising. It did not want anyone drinking.

How Dry We Weren't

On the evening before prohibition went into effect nationwide, on January 15, 1920, the temperance movement was rejoicing—this was the pinnacle of its achievement. The most prominent drys in the country—people like Reverend Howard Russell and Wayne Wheeler of the Anti-Saloon League; Bishop James Cannon, chairman of the Commission on Temperance of the Methodist Episcopal Church; Anna Gordon of the WCTU; Congressman Andrew Volstead; Secretary of the Navy Josephus Daniels; and William Jennings Bryan—all gathered at the First Congregational Church (945 G Street, Northwest), just two blocks from Calvary Baptist. The church was organized in 1865 as a racially integrated church. Oliver O. Howard, who founded Howard University, was a Civil War general who insisted that blacks and whites have a place to worship together. The building was torn down in 1959, and a modern church replaced it two years later. That structure was demolished again; currently the site is a mixed-use high-rise, including a new church.

Bryan delivered an apoplectic speech near midnight, comparing the liquor traffic to those who, like King Herod, would kill the infant Jesus: "They are dead that sought the young child's life! They are dead! They are dead!" He claimed that prohibition would soon become a global movement, spreading from the United States to Europe and the rest of the world. The world would go dry.

Meanwhile, down in Norfolk, Virginia, a former baseball star and evangelist named Billy Sunday delivered the eulogy at a mock funeral for John Barleycorn—complete with casket and a costumed Satan. "Men will walk upright now, women will smile and the children will laugh. Hell will be forever for rent," Sunday promised the thousands gathered. "Goodbye, John! You were God's worst enemy and the devil's best friend. Farewell! I hate you with a perfect hate, and by the grace of God, I love to hate you!"

The next morning, prohibition went into effect. In Demon Rum and John Barleycorn's place was born a sober John Drinkwater. But things didn't work out quite as the temperance movement expected.

Woodrow Wilson's Wine

Woodrow Wilson was the president of the United States when prohibition went into effect in 1920. A devout Presbyterian and Democrat, Wilson personified the Progressive Era of the early 1900s, when government was seen as having an active role in improving American society. He was president from 1913 to 1921. Wilson's first term was about reform and keeping the United States out of World War I. The second term was about winning the Great War and the peace afterward (as he famously said, "The world must be made safe for democracy"). He articulated the country's war aims in the Fourteen Points and saw three constitutional amendments pass into law. The Seventeenth Amendment provided for direct election of U.S. senators, the Nineteenth Amendment gave women the right to vote and the Eighteenth Amendment, as you know, established prohibition.

Wilson was a man of the South, having been born in Staunton, Virginia, in 1856, just before the Civil War, and raised in Augusta, Georgia. The son of a Presbyterian minister of Scotch-Irish descent, Wilson was never a heavy drinker, but like his father he enjoyed an occasional whiskey. He didn't lift a finger to support the prohibition amendment—he believed that this was best worked out at the state and local level—though he did eventually endorse women's suffrage.

Literary critic H.L. Mencken didn't think highly of Wilson—or indeed any politician for that matter. He called Wilson "the self-bamboozled Presbyterian, the right-thinker, the great moral statesman, the perfect model of the Christian cad."

Wilson's first wife, Ellen, died in August 1914, just as World War I began. He was desperately lonely, and the following April he began dating a local widow, Edith Bolling Galt, a cosmopolitan Virginia woman who owned a jewelry store. They were married in December 1915, just fifteen months after

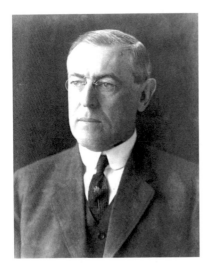

Woodrow Wilson was president when the Prohibition era began on January 16, 1920. He was politically savvy enough to steer clear of the dry cause and so never crossed swords with the Anti-Saloon League. *Prints and Photographs Division, Library of Congress.*

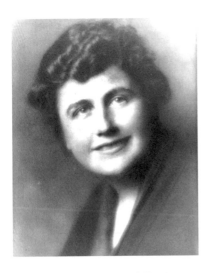

Edith Wilson was Woodrow Wilson's second wife. She was with him when he suffered a stroke on October 2, 1919, and some believe that she was the "president in petticoats" during his recovery. *Prints and Photographs Division, Library of Congress.*

Ellen's death. One of the tour guides at the Woodrow Wilson House once told me, "Wilson was simply a man who *had* to be in a relationship. He wouldn't know what to do with himself if he were single." Edith was intelligent, dark-haired, fair and well connected. She was outgoing, fashionable and financially independent but also devoted to Woodrow and stood by him through the defeats of his presidency and his declining health. Her biographer, Kristie Miller, wrote that Edith's "vitality revived the grieving president."

After Germany surrendered in November 1918, Wilson set sail for the Paris Peace Conference, where he would personally negotiate with the Allies. With the exception of a short break, he was outside the United States for six months, governing the country from Europe. He returned to Washington with the Treaty of Versailles in hand in July 1919 but found the Senate set against its ratification. Republicans had swept both houses of Congress in the 1918 midterm elections (the GOP would hold Congress for twelve years), and Wilson unwisely didn't invite any Senate Republicans to participate in the peace conference. It was a crucial misstep.

Rather than compromise, Wilson set out on a month-long whistle-stop campaign to gain public support for the treaty. During the nationwide trip he suffered constant headaches. After one of the best speeches of his career, given in Pueblo, Colorado, the headache became debilitating. Wilson was rushed back to Washington. On October 2,

1919, Edith found him unconscious in a White House bathroom. He had had a right-brain ischemic stroke caused by gradual clotting and persistent high blood pressure, and it left Wilson numb and partly paralyzed on his left side, but he could still speak and write.

For months Edith and Wilson's physician, Dr. Cary Grayson, strictly limited access to the president, as they didn't want anyone to know how bad Wilson was doing, and they wanted him to recover in peace. The president didn't appear at a cabinet meeting for six months. Wilson also did not step down, even though he was physically incapable of being president during his long recovery. Many assume that Edith was the "secret president" during the months of Wilson's incapacitation. Edith insisted that she made no executive decisions during her self-described "stewardship." She wrote in her memoirs:

> *I studied every paper, sent from the different Secretaries or Senators, and tried to digest and present in tabloid form the things that, despite my vigilance, had to go to the President. I, myself, never made a single decision regarding the disposition of public affairs. The only decision that was mine was what was important and what was not, and the* very *important decision of when to present matters to my husband.*

Edith claimed that she only once ever served as an intermediary between the president and others on official business, "except when so directed by a physician." This was to turn away a British emissary. Her explanation is a little suspect. After all, she controlled access to her husband, and she determined what was appropriate for him to see. Access was everything.

Edith Wilson biographer Kristie Miller concluded that Edith concealed how dire her husband's health really was. Miller wrote, "She personally made high-level governmental decisions, guessing at what Wilson would have wanted. Sometimes she refused to make necessary decisions and prevented others from making them. She did not hesitate to push out longtime Wilson advisers and appointees. Unquestionably she lied—to Wilson's associates, to political leaders, to the press and public."

Just three weeks following the stroke, during the worst part of his illness (Wilson contracted a urinary tract infection), Wilson vetoed the Volstead Act, which enforced prohibition, on October 27, 1919. He believed that beer and wine should remain legal. Edith wrote about Wilson's veto of the Volstead Act in her memoirs: "In his judgment prohibition represented a restriction free people would resent and defy. He believed that the country, through orderly processes in each State, could handle the matter without Federal

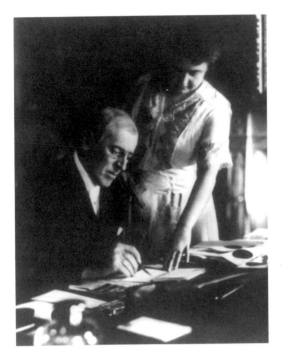

Taken in the White House in June 1920 as Woodrow Wilson recovered from his stroke. His wife Edith screened visitors and summarized issues as his eyesight failed and mobility declined. *Prints and Photographs Division, Library of Congress.*

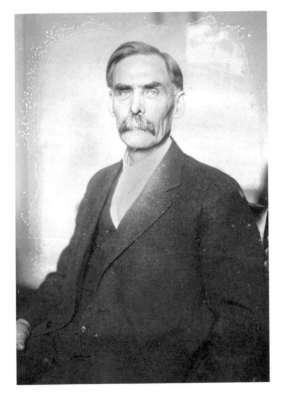

Minnesota congressman Andrew Volstead was the author of the Volstead Act, which enforced prohibition. *Prints and Photographs Division, Library of Congress.*

control, that the law was impossible of enforcement, and must therefore lead to crime and nefarious practises [*sic*]."

Wayne Wheeler of the Anti-Saloon League thought otherwise and fought for a strict definition in the Volstead Act. He considered anything with more than 0.5 percent alcohol intoxicating and thus illegal. Wheeler won this argument, and Congress overrode Wilson's veto the next day.

Virtually incapacitated, Wilson was in no position to lobby on behalf of himself. In fact, given Wilson's fragile condition, it is highly debatable whether he himself actually vetoed the Volstead Act. More likely, his secretary, Joseph Tumulty, wrote the statement for him, based on Wilson's known views of prohibition. Wilson biographer John Cooper concluded that "Wilson's stroke caused the worst crisis of presidential disability in American history, and it had a Dr. Jekyll and Mr. Hyde effect on him. Out of a dynamic, resourceful leader emerged an emotionally unstable, delusional creature."

Every president has departed Washington when they left the White House—every president but Wilson. He was the only president to retire to the city. He was not a wealthy man, having spent much of his career in academia at Princeton University and then in politics as governor of New Jersey. As his term in office was coming to an end, Edith began looking for a new home.

Upon visiting the twenty-eight-room Kalorama town house at 2340 S Street, Northwest, she wrote, "I found an unpretentious, comfortable, dignified house, fitted to the needs of a gentleman's home." Edith told her husband how much she liked the house, so he bought it for her, sight unseen. They paid $150,000, which was quite expensive for the time. The Kalorama neighborhood is now home to many embassies, but in the early twentieth century the neighborhood was crowded with Gilded Age mansions from the nation's richest families, who came to Washington for the high society and to lobby on behalf of their interests. It was a proper neighborhood for a former president.

Wilson left the White House and the presidency on March 4, 1921. He was depressed and defeated. The Democratic Party had rejected him for a third term, and he was unpopular with the American people. His great dream of a League of Nations had been shot down—though he got the Nobel Peace Prize for it. His health was fragile.

Edith claimed that they stayed in Washington because the city was her home and because the Library of Congress would be a valuable resource for Wilson to write a book. She downplayed the fact that her husband's health was so bad that they needed to stay in the district so he'd have access

Woodrow Wilson was the only president to retire to Washington, D.C., and his house in Kalorama is the only presidential museum in the city. He lived there three years until his death on February 3, 1924. *Garrett Peck.*

to healthcare, especially to Dr. Grayson. Wilson was in no condition to write a book—he never got past the dedication page.

The couple filled the house with the state gifts that Wilson had received as a result of the Paris Peace Conference (presidents could keep gifts then; today gifts become the property of the American people). The Kalorama house was quite modern. Built in 1915, it had electricity, and the Wilsons installed an elevator—absolutely vital for a man who was partly incapacitated.

Prohibition had been in effect for more than a year when Wilson left the Oval Office. He had a wine collection, but the Eighteenth Amendment forbade the transportation of alcohol. He didn't want to leave the collection behind for Warren Harding, his successor, so Congress passed a special law allowing Wilson to take the wine collection to his new Kalorama home.

Wilson's wine cellar is probably one of the few Prohibition-era wine cellars that still exist. It is crowded with dusty old bottles. Many are from Bordeaux and Champagne and date from the 1920s. Some of these came into the house after Wilson died; the docents believe that Edith had connections to the nearby French Embassy (former prime minister Georges Clemenceau visited the Wilsons at their home) and probably got a regular resupply from them. In any case, Edith was tastefully discreet and mentioned nothing in her memoirs about having purchased wine during the Prohibition era.

There's an interesting anecdote from the Wilson era about Champagne. Real Champagne only comes from France. The name had been so misused that the French put a clause in the Treaty of Versailles requiring every

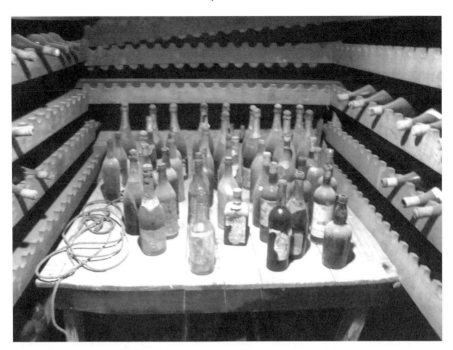

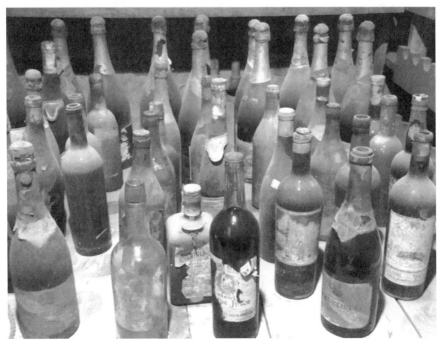

This page: Woodrow Wilson got congressional permission to move his wine collection out of the White House during prohibition. The wine cellar at his Kalorama house is one of the few surviving Prohibition-era collections. *Garrett Peck.*

signatory to stop using the word. However, some American producers today still use the term "Champagne" to describe their sparkling wine. The reason is that Republican senator Henry Cabot Lodge was upset at President Wilson over the League of Nations, which the senator thought would undermine American sovereignty. Lodge ensured that the Senate did not ratify the Treaty of Versailles, and eventually the United States signed a separate peace with Germany but never joined the League of Nations. And that's why some American producers continue to exploit the name "Champagne."

Soon after the Wilsons occupied the house, Herbert and Lou Hoover moved into 2300 S Street, just up the street. The Hoovers lived there for eight years during his tenure as secretary of commerce under Harding and Coolidge. The Hoover house is now the Myanmar Embassy.

Though their Kalorama home was large by any measure, the Wilsons only had a handful of people to help: a chauffeur, a night nurse and, most of all, an African American couple as their servants. "They are Isaac and Mary Scott, of the best of the old-time coloured Virginia stock," Edith Wilson wrote in her memoirs (she wrote graciously about how supportive the Scotts were, but

Mary and Isaac Scott were the Wilson's personal servants and were indispensible in helping the former president in his final years. *Woodrow Wilson House.*

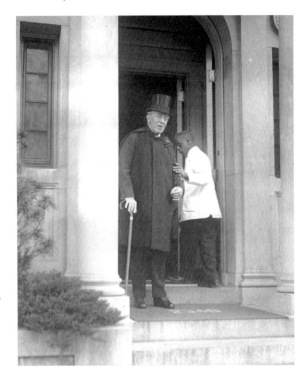

Taken on Wilson's sixty-fifth birthday, December 28, 1921, at his Kalorama home. Wilson's servant, Isaac Scott, was constantly at his side as the former president grew frail. *Prints and Photographs Division, Library of Congress.*

this description still raises a few eyebrows). Isaac was Wilson's manservant, helping the former president get dressed, shave and move about. The Scotts continued to work for Edith long after Wilson passed away.

Woodrow Wilson lived in the house less than three years. He never fully recovered from his stroke, and in time his eyesight and ability to write failed. He died there on February 3, 1924. Wilson's funeral was held in the house, with President Coolidge in attendance. He was buried in the National Cathedral. Edith lived in the house until her death in 1961, entertaining every First Lady from Mrs. Harding to Mrs. Kennedy. Many of the furnishings in the house are original. Edith recognized the importance of Wilson's legacy. She thus preserved the house and donated it to the National Trust for Historic Preservation. Today the Woodrow Wilson House is the only presidential museum in Washington, D.C.

On March 4, 1921, as Woodrow Wilson was departing the White House, Warren Harding was moving in. He brought with him a large supply of liquor, purchased before prohibition began. But unlike Wilson, he never asked permission. He simply did it. Harding was quite wet in his personal life. He often invited his friends over to the White House for

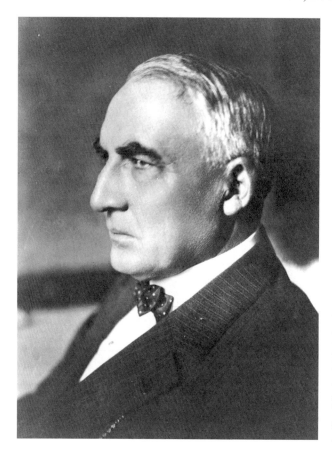

Warren Harding is considered the worst president in American history for the many scandals in his administration. He was no friend to the dry cause and actively consumed liquor in the White House. *Prints and Photographs Division, Library of Congress.*

epic poker games, where cigar smoke clouded the room and the whiskey flowed freely.

Harding's greatest promise was to return the nation to "normalcy" after the many sacrifices of World War I. Widely considered by historians to be the worst president in American history, Harding was credulous and gullible and allowed his Ohio Gang cronies to do as they pleased, though that ultimately damaged his reputation. He served less than three years, as he died on August 2, 1923, replaced by his reticent vice president, Calvin Coolidge. Harding seems to have realized, shortly before his death, how deeply his friends had betrayed him.

After Harding's death, scandal after scandal broke from the Ohio Gang. These men had regularly met, drank, smoked and played poker at the Little Green House (1625 K Street, Northwest). They also cooked up schemes to defraud the taxpayers. The most famous was the Teapot Dome Scandal,

The Little Green House was the headquarters of the Ohio Gang, President Harding's friends who looted the national treasury. Once residential, K Street has since been redeveloped into a commercial strip. *Prints and Photographs Division, Library of Congress.*

whereby Secretary of the Interior Albert Fell secretly leased out part of the nation's strategic oil reserve in exchange for a huge bribe. Veterans Bureau chief Charles Forbes pocketed large sums that should have gone to veteran services, while attorney general Harry Daugherty took kickbacks from lawyers seeking to restore property that was seized from the Germans during World War I. Other members of the Ohio Gang took bribes from bootleggers in exchange for federal protection. Frederick Lew Allen, the chronicler of the 1920s, concluded that "the Harding Administration was responsible in its short two years and five months for more concentrated robbery and rascality than any other in the whole history of the Federal Government." The Little Green House, which was the boilermaker for so many of these scandals, was demolished in 1941. The Commonwealth office building stands there today.

The Bottom
of the Barrel

Thanks to legions of German immigrants, beer became the nation's most popular alcoholic beverage after the Civil War. Washington was no different. The city had a thriving brewing culture, and local breweries struggled to keep up with insatiable demand. With hot and humid summers, lager beer was just the ticket to take the edge off the season. In 1916, district residents drank 7.2 million gallons of beer and 1.6 million gallons of whiskey, wine and other spirits. Beer was so prevalent that temperance advocates took to calling Washington the "Sodom of Suds." Their victory in prohibition meant the loss of a vibrant brewing culture.

Local historian Cindy Janke, who lives on Capitol Hill, led me on a walking tour and explained how extensive the city's brewing culture was. There were four local breweries in the city, all closed down by prohibition. Two were located on Capitol Hill, and the other two in Foggy Bottom. Other brewing-related businesses were affected as well: German Brewing from Cumberland, Maryland, and Monument Brewing from Baltimore both had local offices, and there were a number of bottling companies that supported the local brewers, such as Arlington Bottling and Herrmann Bottling. Three national brewers—Anheuser-Busch, Pabst and Schlitz—maintained bottling plants in the district. They'd ship beer barrels in by rail and then bottle the beer for local distribution.

By far the largest local brewer in Washington was the Christian Heurich Brewing Company, which was located at Water and Twenty-fifth Streets in Foggy Bottom. Just a block away was the city's smallest brewery, the Abner-Drury Brewing Company (2524 G Street, Northwest). On Capitol Hill, two breweries supplied the city's thirsty inhabitants: the Washington Brewery (the entire city block at F and Fifth Street, Northeast) and the National Capital

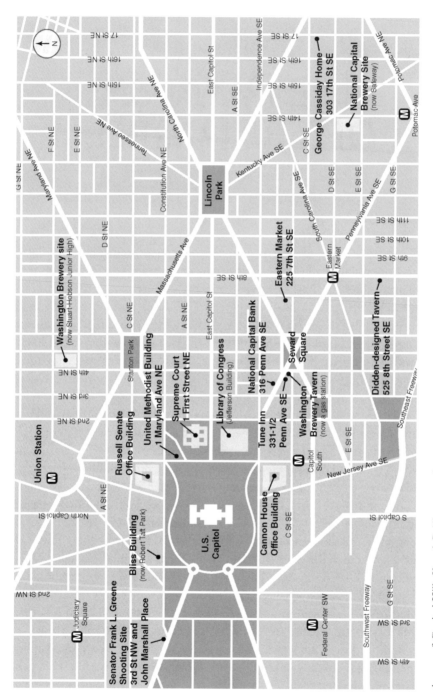

A map of Capitol Hill. *Kenneth P. Allen, mapmaker.*

Brewery (Fourteenth and E Streets, Southeast). With the exception of Abner-Drury (run by an Irishman, Peter Drury), German immigrants owned and operated all of the breweries.

German immigrant Albert Carry moved to Washington in 1886 when he purchased the Juenemann Brewery in Northeast. He had managed a large brewery in Cincinnati and was eager to make his mark in a city with fewer competitors. He modernized the Juenemann facilities and then sold them off three years later to a group of New York investors who may have fronted for a British brewing syndicate. The new owners

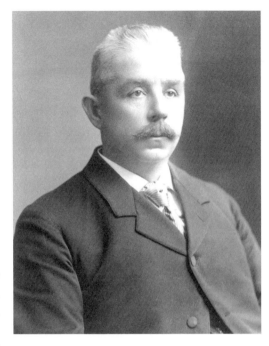

A portrait of Albert Carry, a German immigrant and founder of National Capital Brewery and National Capital Bank. *Jimmy Didden.*

named it the Washington Brewery. The brewery even owned a tavern, located in an eighteenth-century building at Fourth Street and Pennsylvania Avenue, Southeast. This stood until 1931 and then was torn down. It's now a gas station, just a couple doors from Tune Inn.

Capitol Hill had three major employers in the nineteenth century: Congress, the Washington Navy Yard, and two large breweries. However, it had a major problem: it lacked a bank. Albert Carry spotted a business opportunity and invested the profits from selling the Juenemann Brewery to form the National Capital Bank, an institution that still stands at 316 Pennsylvania Avenue, Southeast. He must have still longed for his brewing days, as Carry bought the Rabe Brewery at Fourteenth and D Streets in Southeast and combined operations with the Robert Portner Brewery Company of Alexandria. He dramatically modernized and expanded the facilities into a 100,000-barrel-a-year operation that opened in 1891. Carry named it the National Capital Brewery. Its primary product, like all of the local breweries, was lager beer.

Besides Adolf Cluss, there were a number of German-born architects who had immigrated to Washington. Clement Didden was one of them, and

he became Albert Carry's architect and designed the brewery's expansion. One of the surviving buildings that Didden designed for Carry was a tavern for the National Capital Brewery (525 Eighth Street, Southeast, which over the decades has been a series of gay bars). The alliance between the Carry-Didden families was sealed when Didden's son, George, married Carry's daughter, Marie.

The Carry-Diddens built their fortune on banking, brewing and real estate, but prohibition made brewing untenable. Carry converted the chilling plant at the brewery to make ice cream, and the Carry's Ice Cream brand was born. The company teamed with the budding Dixie Cup Company in 1923 to sell five-ounce cups of ice cream, an instant success. Carry lived until 1925, and the family sold off the ice cream factory. Fortunately, they still had the bank to fall back on.

Jimmy Didden is the president at National Capital Bank on Capitol Hill. It is still very much a family-owned business, with its two bank branches. His three other brothers—great-grandsons of Albert Carry and Clement Didden—are all in the senior management of the company. Richard is the chairman—and it turns out that we live in the same building. Jimmy's son, Bill, was our building manager for a number of years. Of course, I didn't know of the family connection until I walked into Richard's office to see the family archives.

Jimmy is the family historian, the one who collects brewing memorabilia. He led me to the bank's boardroom, where he pulled out a wine box full of

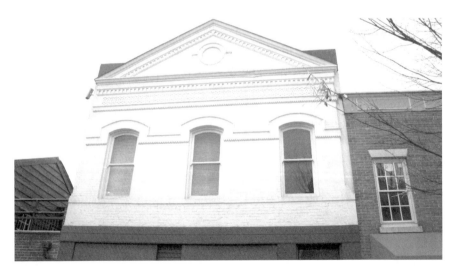

Clement Didden, architect for Albert Carry and the National Capital Brewery, designed the bar at 525 Eighth Street, Southeast. *Garrett Peck.*

Right: A stylized 1895 calendar from the four-year-old National Capital Brewery on Capitol Hill. *Jimmy Didden.*

Below: A pair of small ceramic mugs celebrating the National Capital Brewery on Capitol Hill. *Jimmy Didden.*

53

breweriana and family history—brown beer bottles, lots of Carry Ice Cream mementos and two small National Capital Brewery mugs that are his pride and joy.

Carry doesn't sound German, so I asked him if "Carry" was Anglicized—just as Shoomaker was once Schuhmacher. Jimmy said with a twinkle that it wasn't. One of his relatives who is into genealogy discovered that the Carry family was only in Germany for five generations—the name was really Carri and had come from Lago di Como in Italy.

A week later, I joined the DC Collectors, an informal group of breweriana collectors who met at a private home. Our host, Jack Blush, had a finished basement that was practically a museum of brewing memorabilia. Rayner Johnson is the group's organizer. He has led the Blue and Gray Show, an annual breweriana meeting in Fredericksburg, Virginia, since 1979.

"I started collecting beer cans in 1975. I went to the Brickskeller [a Washington institution that had an astonishingly large beer list] to drink some Stroh's and saw all of the different beers and that was it," Johnson said. The Brickskeller (open from 1957 to 2010)—now the Bier Baron—has walls covered with thousands of beer cans.

The DC Collectors gather to show off members' collections and trade for items. We sipped really good beer, and the members laid out their prize collectibles on a ping-pong table. It was amazing to see the artwork that brewers developed to sell their beer: bottles, calendars, salt-and-pepper shakers and artistic labels, not to mention every kind of sign imaginable. Rayner said that DC Collectors has the largest and most unique collection of Washington breweriana around.

Breweriana is not the only thing that survives from a once rich brewing culture. The most lasting landmark is the Christian Heurich House Museum, better known as the "Brewmaster's Castle" (1307 New Hampshire Avenue, Northwest). It is a high Victorian mansion built south of Dupont Circle in 1892–94 by German brew master Christian Heurich (pronounced HI-rick), who first started brewing beer in Washington in 1872 after immigrating to the United States just six years before. The house is one of a kind, built of poured concrete and reinforced steel so as to be fireproof. It looks, quite literally, like a medieval castle.

Heurich came from a brewing family. Upon moving to Washington in 1872, he partnered with Paul Ritter to buy out the Schnell Brewery at 1229 Twentieth Street, Northwest. Three years later, Heurich bought out Ritter and was now the sole proprietor. He steadily ramped up production as he tapped into the thirsty beer market, reinvesting in the business until he no longer had

capacity. In 1881, he razed his brewery and built a larger, four-story complex capable of producing fifty thousand barrels of beer annually. By 1890, Heurich was producing twenty labels, and his brewery was capitalized at $800,000—a significant sum at the time. He invested heavily in real estate, becoming the largest private landowner in the district.

Despite being made of brick, the Christian Heurich Brewery seemed to attract fire. Damaging fires broke out in 1875 and 1883, but the most significant one nearly gutted the brewery in 1892. Not one to give up, Heurich started over,

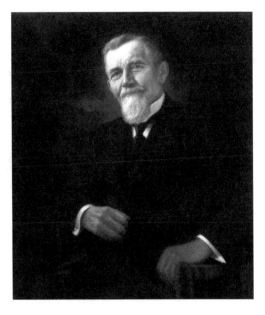

A portrait of Washington brewer Christian Heurich. He died in 1945 at the age of 102. *Historical Society of Washington, D.C.*

far more ambitious than ever before. He began constructing a new brewery in Foggy Bottom, right on the Potomac River. He expanded operations tenfold, building capacity to support 500,000 barrels a year. It began brewing in 1895. Senate lager was the brewery's leading brand.

Heurich also needed a new home. He owned a plot of land two blocks north of the gutted brewery, and that's where he decided to build his castle. His new home and the new brewery in Foggy Bottom were virtually fireproof, constructed of reinforced steel and concrete. The house has seventeen fireplaces, none of which has ever been lit. The pyrophobic Heurich simply wouldn't tolerate a fire in his home. Instead, the fireplaces conveyed status.

The Christian Heurich House is wedge-shaped, angled back by New Hampshire Avenue and facing Twentieth Street, Northwest. It is a thirty-one-room mansion that delights in medieval and Old World style. Heurich employed twenty servants to run the house and serve his family. Best of all, the house is original, with most of its 1890s-era fixtures intact. It conveys old money, but it was built entirely with a new fortune. Heurich was quite the entrepreneur. He earned his fortune himself rather than inheriting it, and he was a philanthropist. He also frequently traveled, crossing the Atlantic seventy-three times.

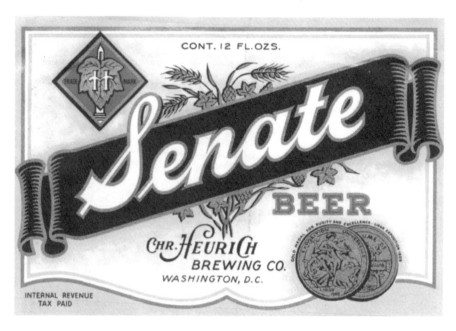

A post-prohibition beer bottle label for Senate Beer, the Christian Heurich Brewery's best-known brand. *Rayner Johnson.*

Known as the Brewmaster's Castle, brewer Christian Heurich built this fireproof house in Dupont Circle in 1892–94. It is the last remaining evidence that Washington once had a thriving brewing industry. *Garrett Peck.*

Heurich's second wife died just four months after the Brewmaster's Castle was completed. Heurich still had no children, and as he grew older, he wanted heirs. He married his third wife, Amelia Keyser, in 1900. There was a twenty-eight-year age difference between the two. She became the mother to his children so the Heurich family name could live on.

The best part of the house is the *Bierstube* that Heurich installed in the basement for his friends to drink and romp the night away. It has a keg alcove and a tavern-like room, with German proverbs that celebrate drinking on the walls. Scott Nelson, the executive director of the Heurich House, quipped, "The basement was the original man-cave." Amelia Heurich grew tired of her husband's late-night drinking fests and converted the cellar into a breakfast room.

During the anti-German hysteria of World War I, the federal government searched Heurich's mansion twice for Kaiser-leaning materials. He was so angry at British propaganda against the Germans that he moved his insurance policies and finances from British to American companies. Heurich believed that this was the source of his troubles with the government. He wrote in his 1934 memoirs: "Germany was and is my mother, and I was against the war. But America is my bride, and if I have to choose between the two, then I must leave my mother and go with my bride. My whole existence is with my bride, America."

Heurich planned contingencies before the Prohibition era in the district began in November 1917. One idea was to convert the brewery to produce nonalcoholic apple cider. Americans hadn't drunk apple cider since the 1840s, so it took time to build a market. Even though Heurich pasteurized the apple juice to halt fermentation, the brewer discovered about eighteen months into the experiment that the cider had somehow fermented. "This apple wine surpassed everything in quality; however, because of its alcohol content, we could not sell it," he wrote. He put the barrels full of cider in storage, hoping that he could sell the beverage one day.

Heurich was the second-largest employer in the city after the federal government. He treated his workers well and rapidly reached accommodation on labor issues. During prohibition, he reached an agreement with his five hundred workers that would lower their pay but also keep the brewing facilities open so they could maintain their jobs. As the brewery had an ice plant, Heurich's chief product during prohibition became ice. That left most of the facilities unused, as Heurich complained: "The buildings have been idle since 1917 when prohibition began in the District of Columbia, but I still have to pay high taxes on them."

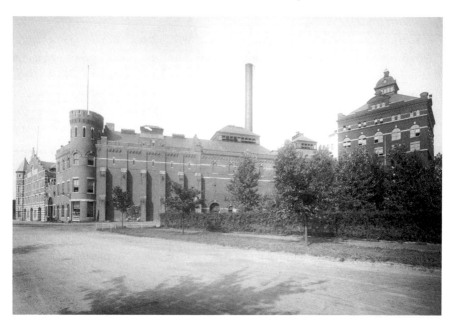

The Christian Heurich Brewing Company was Washington's largest and operated along the Potomac River until 1956. It is now the Kennedy Center site. *Prints and Photographs Division, Library of Congress.*

African Americans were employed at the brewery, but only in low-level, low-wage jobs. This was, in part, because the Brewery Workers Union reserved better-paying jobs in office work, sales and delivery trucks for its whites-only members. After the New Negro Alliance protested, Heurich agreed to open 140 truck-driving jobs to black workers in 1940. As Heurich was such a large employer, his decision spilled over into a number of other businesses.

Prohibition had closed most of the nation's breweries, and few of them attempted to reopen afterward. After repeal in 1933, a few national brands—Pabst, Schlitz and Anheuser-Busch—all emerged intact and soon began crowding out the local beers. By the 1950s, the market had consolidated into a handful of national producers. Local brewers all but disappeared. This was long before the craft beer revolution of the 1980s brought local beer back to the fore. American beer became defined by light, watery lager that has little character beyond refreshment.

Neither one of the Capitol Hill breweries reopened after prohibition. Their buildings were demolished and redeveloped. The Washington Brewery was torn down in 1927 and is now the location for Stuart-Hobson Junior High.

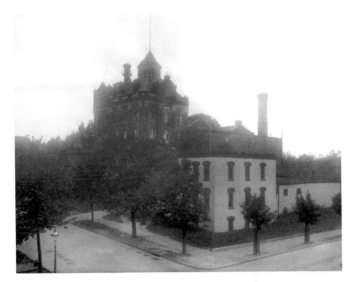

The Washington Brewery took up an entire city block on Capitol Hill. Prohibition closed the brewery in 1917. *Prints and Photographs Division, Library of Congress.*

The Washington Brewery on Capitol Hill was leveled in the 1920s and replaced by Stuart-Hobson Junior High. *Garrett Peck.*

The National Capital Brewery was leveled in the 1960s to make room for a Safeway grocery store. However, the town houses on the southeast corner of the parking lot are original to the time of the brewery.

Both breweries in Foggy Bottom—Christian Heurich and Abner-Drury—reopened after repeal. Heurich brought its first batch of 3.2 percent beer to market in August 1933. Heurich needed space to age the beer, and as the barrels full of apple cider took up much of his storage (and which at 6 percent alcohol was still illegal to sell), he ended up dumping the cider in the sewer. All of that investment went, literally, down the drain.

Heurich also discovered that the public's appetite for beer had declined noticeably. The same pre-prohibition fervor for beer was gone, as people had

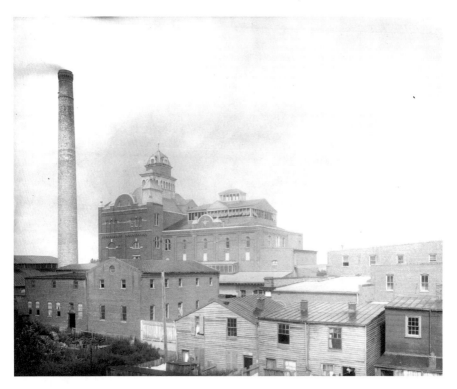

The National Capital Brewery opened in 1891. It was one of two Capitol Hill breweries closed by prohibition and was converted to make ice cream. *Prints and Photographs Division, Library of Congress.*

The National Capital Brewery was leveled in the 1960s to make room for a Safeway grocery store. *Garrett Peck.*

grown accustomed to bathtub gin and whiskey. Although Heurich trudged along, Abner-Drury quickly ran into financial difficulties and shuttered just two years after repeal. There is no remnant of the nine-building complex. It was located where New Hampshire Avenue crosses Virginia Avenue on the approach to the Watergate.

Christian Heurich lived an exceptionally long life, and he continued working nearly until his death in 1945 at the age of 102. In his memoirs he concluded, "This is my life, and if it was much, it was trouble and work." Ain't that the truth.

Heurich's wife, Amelia, died in 1956, and the brewery was closed that same year. It was the end of an era. The family donated the valuable property along the Potomac River to make way for the Kennedy Center. It took three days of dynamiting in 1961 to take down the fortresslike structure.

Amelia willed the Heurich House to the Columbia Historical Society (now the Historical Society of Washington, D.C.). The Heurich House served as the society's offices for forty-seven years. In 2003, the society moved to the Carnegie Library at Mount Vernon Square, and Heurich's letters and archives were transferred there as well. The following year, several of Heurich's grandchildren bought the home back and gifted it to the Heurich House Foundation. It is now a full-time museum.

Heurich's grandson, Gary Heurich, attempted to bring back Olde Heurich and Foggy Bottom beer in the late 1990s, producing it through a contract brewer in Upstate New York. Unfortunately, the beer didn't take in the local market, and Gary folded the operation in 2006.

The Brewmaster's Castle—the Christian Heurich House—is the only remnant of Washington's once rich brewing culture. The rest of it—every brewery, every barrel and every building—was lost, demolished for redevelopment. Prohibition obliterated Washington's breweries and all but the memory of them. The nation's capital had once been the Sodom of Suds, but the suds were no more.

THE JIM CROW ANNEX

S o much of the press we read about the Prohibition era in Washington is about white people's involvement in the noble experiment. Washington was a largely segregated city until the 1950s; not only were many public areas divided between black and white sections, but there were also dividing lines in neighborhoods. The mainstream press refused to address black issues. Jim Crow racism meant keeping blacks "in their place," which was at the bottom of the socioeconomic ladder. The 1920s was the heyday of the Ku Klux Klan.

As a result, the African American community had to find its own way to economic freedom and political independence. There was a segregated school system, black newspapers and, perhaps most famously, a black baseball league, the Negro League. So little was reported on black Washington that historian Constance McLaughlin Green called it the "Secret City."

The story of prohibition's impact on Washington's black population has largely been untold, and it has long been ignored. At the start of the Prohibition era in 1920, 109,966 African Americans lived in a city that numbered 437,571 inhabitants. During the Great Migration (1915–30), about 2,000,000 blacks left the South for northern cities and new opportunities. This era largely overlaps with the Prohibition era. By 1930, the black population reached 132,068 people, swelled by the Great Migration, out of 486,869 residents. Washington was about one-quarter African American.

Washington had the most prosperous black community in the country and was the second largest after New York's. There was a significant professional class, and many middle-class families lived in good neighborhoods like Ledroit Park, Quality Row and the Strivers' Section. Many merchants and entrepreneurs opened shops along the bustling U Street corridor. But there was also a great deal of poverty.

The African American community was divided along social and class lines, just as was the broader society around it. The major difference was in pronounced segregation from the dominant white society. Washington had a group of black "aristocrats," about one hundred families who counted themselves the elite (though they were typically called the "black 400"). For the most part, they were educated professionals.

The elites didn't look kindly on the poor, "unimproved" blacks moving into the city from the Deep South. Classist resentment ran in both directions. The former demanded respectability and lavish homes with servants, while the poor lived in alley dwellings. But even Jim Crow laws increasingly affected the black elite, as they, too, were segregated and pushed out of federal employment and white-collar positions.

Wealthy black society was typically Episcopalian and Presbyterian (*the* elite black church was Fifteenth Street Presbyterian, followed by St. Luke's Episcopalian), but the mass of black population was Methodist and, especially, Baptist, two evangelical churches that were leaders in the temperance movement.

"Proper" African Americans of the time called themselves "colored," an anachronistic term today. Newspaper articles of the era would usually give the person's name, followed by "colored," something they didn't do for white people. Thus it is relatively easy to spot many African Americans who were engaged in bootlegging. That said, the press wouldn't report news about the black community—supposedly it didn't interest white readers. This was institutional racism.

So what did black people think about prohibition? It's a complicated question, but before attempting to answer that, we first have to set the stage by explaining one of the most violent events in Washington's history. This came just six months before national prohibition began.

THE 1919 RACE RIOT

A brutal race riot broke out in Washington, D.C., starting July 19, 1919. It was as close to a race war as this nation has seen. It lasted four days, by the end of which the black community realized that it could stand up and defend itself.

The summer of 1919 has been called the Red Summer. In the collapse of European empires after World War I, the Bolsheviks had taken over Russia, organized labor was agitating and there was tremendous fear that communist

insurgents would come to the United States. This irrational fear helped set off race riots in more than twenty American cities that summer, including Charleston, Chicago, Knoxville, New York, Omaha and Washington.

Washington had grown by 100,000 people, mostly whites, since entering the Great War two years earlier. The city was overcrowded with temporary war workers and discharged soldiers. There was a housing shortage and, with the war over, a job shortage as well. Many transplanted whites resented the relatively well-off position of blacks in the city. Likewise, the black community resented Jim Crow laws that chipped away at their freedom. President Wilson's administration had dismissed many African Americans from government and tolerated separate water fountains and restrooms to be built in government offices. Hundreds of thousands of young black men had fought in the war (five thousand from the district) and soon became more assertive about their rights as citizens. Furthermore, newspapers sensationalized black-on-white crime. It was just a question of time before the race question exploded.

What touched off such violence? It was the peak of summer, and Washington was a hot, sticky steam bath. In this muggy tinderbox, the local newspapers falsely reported that several black men had assaulted a white woman—a service member's wife. "Negroes Attack Girl—White Men Vainly Pursue," as the *Post* reported sensationally on Saturday, July 19. As if on cue, several thousand white men leapt into action to defend her honor.

Whites from Hooker's Division—including hundreds of off-duty sailors and soldiers stationed in Washington—gathered at the Knights of Columbus hut at Seventh Street and Pennsylvania Avenue (near the Temperance Fountain) and marched to attack Southwest, beating up blacks they encountered on the streets. The next evening, the white crowd gathered again, and the violence grew more severe as it escalated across the city. The outnumbered police could do little to stop the broiling crowd. At this point, the black community began organizing for resistance. When a white mob ascended Seventh Street to assault the U Street corridor, the heart of the black community, they encountered about one hundred black men at Florida Avenue. The two groups came to blows before the whites dispersed.

On Monday, while local authorities attempted to bring calm to the city, the *Washington Post* fanned the flames by calling for a white mob to finish what they started ("Mobilization for Tonight" read the headline). Learning this, many blacks armed themselves with guns and began firing at white people, sometimes randomly from cars. The violence escalated. When a mob of whites moved up Seventh Street, a large number of armed black men confronted them at T Street near the Howard Theatre. The police attempted to intervene, and one

of them, Officer Herbert Glassman, was cited for bravery (Glassman would later run the city's largest liquor ring). Again the whites retreated.

President Woodrow Wilson had just returned from the Paris Peace Conference the week before, yet he did little to stop the violence. Like many whites in the country, he hoped that the race problem would simply go away. On Tuesday, July 22, he finally responded to the riots after realizing that the local authorities were in over their heads. Wilson ordered two thousand soldiers, sailors and marines to restore order. These troops separated the two sides and dispersed gathering mobs. The riots finally ended that evening with a torrential rainstorm that sent everyone home.

Black soldiers returning from World War I had hoped for recognition for their contributions, but instead they were attacked in their own neighborhoods. "This Nation's Gratitude" read the *Washington Bee*'s headline on July 26, dripping with accusation. Hundreds of thousands of black men had fought for their country, only to find that democracy and freedom at home apparently didn't include them.

In a city approaching half a million people, the seven-hundred-person Metropolitan Police Department proved inadequate to the task of restoring peace and protecting the population. African Americans knew this, and thus they armed themselves. The *Bee* editorialized, "The black man is loyal to his country and to his flag, and when his country fails to protect him, he means to protect himself."

What surprised many was the vigilance in the African American community at countering the attacks. Formerly, African Americans were expected to do what white people told them; instead, the black response to the riots was defiance. That the black community didn't step aside was a key step in asserting black identity. African Americans learned the hard way that they literally had to fight for their rights. James Weldon Johnson of the National Association for the Advancement of Colored People (NAACP), who came to Washington to investigate the riots, remarked, "The colored men will not run away and hide as they have done on previous occasions of that kind. The experience here has demonstrated clearly that the colored man will no longer submit to being beaten without cause."

The aftermath from the riots was lengthy and ugly. Many whites wanted to put it behind them, but the black community demanded justice. Nine people had been killed, and more than thirty died of wounds. Hundreds were injured. The *Bee* complained that most of the people arrested were black, yet the riot was white-instigated. Likewise, it was mostly black citizens who were sent to prison for rioting or firing guns.

This palpable anger over the race riot—and the ensuing sense of defiance—helped frame how African Americans responded to national prohibition. The start of prohibition went almost unnoticed in the black press; the concerns were about justice and monetary restitution for the riots. Frankly, Washington's black community was still in shock from the rioting just six months before. Many decided that prohibition was the white man's law—a racist law specifically designed to control black people—and they weren't going to obey it.

Prohibition and Washington's Black Community

What can we conclude about black attitudes toward prohibition? There is no easy answer, given the large size of Washington's black community, its class structure and the dearth of reporting about prohibition. Few black newspapers wrote about dry law. They were far more concerned with bread-and-butter issues like fairness in employment or life-and-death issues like lynching. Prohibition was rarely on the radar.

I should caution against viewing African Americans as a monolithic community with a single voice. Theirs was a very large community, and no doubt there was a wide array of opinions about prohibition. Many black pastors preached the evils of Demon Rum, and some intellectuals like Kelly Miller likewise painted the debate in terms of morality and law and order. Others, like newspaper editor Calvin Chase, realized that temperance was, in part, targeted at them by racists who believed that alcohol made black men more dangerous. Like the black press, many African Americans were indifferent. They had other priorities.

Many African Americans saw prohibition as a business opportunity, including selling to whites who came to their part of town to misbehave. Speakeasies became far more racially integrated. Transplanted blacks from the Deep South were often poorly educated and had no skills. They came to cities with a much higher cost of living and few job prospects. Bootlegging was open to everyone, and there was good money in it. Seldom did people wonder if this was a good thing.

Let's take a look at some of these varied opinions, starting with Calvin Chase. Newspapers were the primary source of information for people in the early twentieth century. While there were a number of black publications in the nation's capital, the most influential was the weekly *Washington Bee*, published by W. Calvin Chase from 1882 until his death in 1922. His office

W. Calvin Chase was the editor of the *Washington Bee*, a weekly local newspaper for the African American community. His downtown office was at 1109 I Street, Northwest. *Prints and Photographs Division, Library of Congress.*

was located at 1109 I Street, Northwest, which was also his home. Chase documented possibly the worst years of black-white relations in American history, which was the era of lynching. He was a protest writer, one who demanded that the federal government stop the violence against African Americans.

Chase was born free in 1854 in Washington; his parents were free, working-class people. Educated and part of the professional class, Chase worked with his wife and two children to publish the *Bee*. The character of the *Bee* reflected Chase's views; this was personal journalism, and as editor, his imprint was on every article Chase was no temperance advocate. In 1907, he questioned, "Must there be a law passed to prohibit people from drinking whiskey? Because one man doesn't drink intoxicants, is there any reason to say that another person shall not drink them?" He continued: "Why should we have prohibition in this city? The Bee believes in personal liberty and believes that people have sense sufficient to know right from wrong…Intoxicants are absolute necessities. Whiskey is no more dangerous than anything else when properly used and judiciously handled."

Chase was unapologetic in denouncing the dry movement. "There is no bigger set of rascals in the world than temperance advocates," he wrote in 1908. "The greatest shams in town are the temperance shams," he wrote a year later.

The temperance movement had a racist angle, which Chase was quick to pick up. He asserted that if the black community embraced the dry cause, it would be complicit in institutional racism. He asked rhetorically,

"Why should the colored people ally themselves with a white temperance organization as a 'Jim Crow' annex?"

Fast-forward to a decade later, and Chase had nothing to say in print about prohibition, the Sheppard Act or the Volstead Act. His silence was striking. Instead, his attention was riveted to the fallout from the 1919 race riot. The only vague reference to prohibition in the *Bee* was a small advertisement that ran week after week for Keystone Laboratory. "Make Beer, Wine and Liquor at Home," read the ad headline. "We are offering formulas, with full instructions for making at home with ordinary household utensils, delicious, creamy lager beer (not near beer); also fine flavored wine and mellow, smooth liquor; and don't forget that any one of them will have all the kick you want."

Alcohol provided a livelihood for many black Washingtonians. Before the Prohibition era, nine hundred men had served as porters in local bars. Cocktail historian Charles Wheeler spoke with wonder about the black bartenders who had practiced a "lost art" that disappeared with prohibition. "It may well be conjectured whether anyone today knows exactly how to make that celebrated 'Flower Pot Punch,' like those old darky servitors [*sic*] used to prepare at Hancock's Bar," he wrote nostalgically in 1926. Most of the city's bartenders had been white, though that changed with prohibition. Suddenly many career paths, albeit illegal and illicit, opened up. Prohibition was undoubtedly an opportunity for many entrepreneurial African Americans who seized the chance to bootleg or open a speakeasy.

African Americans in the 1920s looked to Harlem as their cultural beacon, and Harlem was a den of speakeasies and jazz clubs, often one in the same.

A man carries a case of Four Roses bourbon. Bootlegging was an economic opportunity for many African American during Prohibition. *Prints and Photographs Division, Library of Congress.*

There was little self-criticism in the community about this, even though many speakeasies were fronts for the Mafia, and if anyone got arrested, it would be the African Americans managing the joint, not the white men who fronted the money.

There were African Americans who were dismayed by the endemic lawbreaking that occurred during the Prohibition era. The most outspoken was Kelly Miller, a professor of sociology and the dean at Howard University. He was a frequent commentator in the black press and a prohibition supporter. He wrote in 1923 for the *Afro-American*, "The Negro has a deeper moral interest in the question. Prohibition is vital to the salvation of the race. Whatever evil consequences whiskey may bring to the white race are multiplied by three when applied to Negro."

Miller called the black bootlegger "the greatest enemy of his race." Prohibition was a morally transcendent issue, and if African Americans ignored the Eighteenth Amendment, then it was fair game for whites to ignore the Fourteenth and Fifteenth Amendments that had established black rights after the Civil War.

Miller wasn't alone in supporting prohibition. He claimed that 600,000 African Americans had signed the temperance pledge not to drink, mostly in the South. If true, this would represent a significant portion of black adults who supported dry law. The nation at the time had about 12,000,000 black people.

Writing just a week after the Valentine's Day Massacre in 1929, the *Afro-American* condemned the widespread disregard for the law that prohibition had engendered in the black community. "While it was the most foolish of all things for lawmakers to believe they could regulate such a moral principal by statute, the only thing now to do is to enforce it or change it."

Of all the commentaries I have read on prohibition, none has struck me quite so poignantly as an op-ed that Kelly Miller wrote for the *Afro-American* in February 1932. He nailed the black community's disregard for prohibition. The public debate about ending prohibition was hotly contested, but blacks seemed hardly to care. He wrote:

> *And yet our own newspapers, orators, writers and publicists have stood by and looked on with unconcern as if the matter were foreign to our lives and interests. As a matter of fact, the colored race is the most vitally of all concerned in this nation-sweeping movement. The small scale speak-easies and bootlegging are carried on in large measure by colored agencies under manipulation of master-minds higher up.*

While black ministers had earlier spoken up to denounce drinking, now there was nothing from the pulpit. Miller was, at the end, a lone voice in the wilderness, calling out in vain. The black community had significantly contributed to prohibition's failure by actively undermining dry law.

There are major parallels to other ethnic and religious minorities (Germans, Italians, Irish, Catholics and Jews) whose rights to drink were pushed aside by the dry cause—and who likewise actively disregarded prohibition. The difference is that these people were white, and so their stories were constantly broadcast. African Americans didn't get that treatment in the white press, except when they were arrested.

In the 1920s, a new black identity began to arise, in part as a response to the race riots and the Great Migration. African Americans no longer wished to mimic white society but wanted rather to see themselves unapologetically as black. They shunned the word "colored" in favor of "Negro." The movement was philosophically led by Alain Locke, a Howard University professor who was also a Rhodes scholar. In 1925, Locke published *The New Negro* anthology to demonstrate a new era of black art and culture.

The Great Migration and resistance to Jim Crow, the outcome from the 1919 race riot and the mass disregard for prohibition helped give birth to an awakening in the black community. Some called it the New Negro movement. The result was a flowering of black culture in the 1920s known as the Harlem Renaissance, which manifested itself locally along Washington's U Street.

U STREET

Calvin Chase of the *Washington Bee* called U Street the "Colored Boulevard." It ran between Fourteenth Street and New Jersey Avenue, Northwest. Its eastern anchor was Howard University, the historically black college founded in 1867 that had spawned an unrivaled black professional class. U Street was the cultural center of African American life in Washington starting in the 1880s. Hundreds of black-owned businesses sprouted in the neighborhood, fostering a strong black middle class.

During the 1920s, the street earned a more lasting moniker, one that rivaled Harlem for its renaissance in black business, culture and entertainment. It became known as the Black Broadway. U Street biographer Blair Ruble wrote, "U Street combined in just a few short blocks what took Broadway a half a dozen miles or more to contain stretched out along the spine of Manhattan."

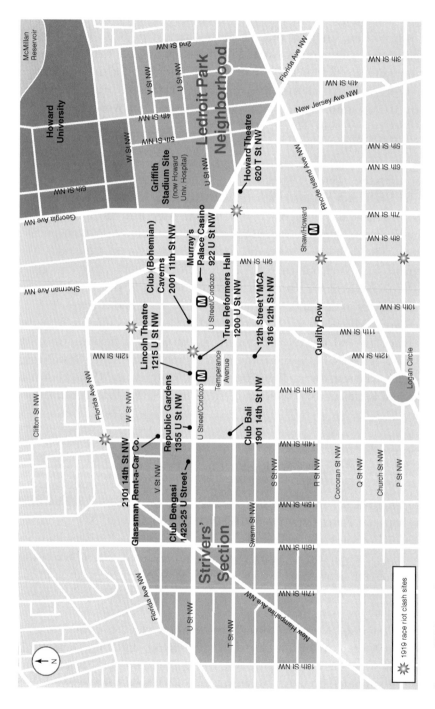

Strivers' Section

Ledroit Park Neighborhood

McMillan Reservoir

Howard University

Griffith Stadium Site (now Howard Univ. Hospital)

Howard Theatre 620 T St NW

Murray's Palace Casino 922 U St NW

Club (Bohemian) Caverns 2001 11th St NW

True Reformers Hall 1200 U St NW

12th Street YMCA 1816 12th St NW

Lincoln Theatre 1215 U St NW

Republic Gardens 1355 U St NW

Club Bali 1901 14th St NW

2101 14th St NW Glassman Rent-a-Car Co.

Club Bengasi 1423–25 U Street

Quality Row

Logan Circle

Temperance Avenue

1919 race riot clash sites

A map of U Street. *Kenneth P. Allen, mapmaker.*

Yet Washington was a southern city, and that meant Jim Crow rules. African Americans couldn't go to the theater or movies with white people; they had to go to theaters of their own. Their children were educated at separate schools. However, the public library at Seventh and K Streets, Northwest, was integrated, and the streetcars lacked a Jim Crow section. African Americans could watch baseball games at Griffith Stadium on the east side of U Street. Though the Washington Senators baseball team was all white, the fans weren't.

In other ways, the heavy wall of segregation began to chip away in the 1920s—and largely because of prohibition. U Street was a hive of activity—a cultural destination for speakeasies and live music such as jazz. This was, after all, the Jazz Age. Just as women had entered speakeasies that were once off-limits to them, blacks and whites began intermingling in ways that they never would have done before. And it was all thanks to jazz and illegal booze.

A 1937 Federal Writers' Project noted this about Washington's black community: "One boast, perhaps better founded than those of culture or civic status, is that Washington Negroes have a good time." And how. U Street was a leading destination for an evening's entertainment. It had pool halls, movie theaters, the baseball stadium, dance halls, jazz clubs, nightclubs, speakeasies and even a few clandestine gay bars concentrated in this vibrant part of town. Alcohol was often secretly part of the mix. So were gambling and prostitution. Vice was often simmering just below the surface. U Street had become a place where naughty white people could play and not get caught.

In 1925, black historian J.A. Rogers noted the downside to jazz's popularity: "The tired longshoreman, the porter, the housemaid and the poor elevator boy in search of recreation, seeking in jazz the tonic for weary nerves and muscles, are only too apt to find the bootlegger, the gambler and the demi-monde who have come there for victims and to escape the eyes of the police." Vice was always just below the surface, and many speakeasies dabbled in prostitution in addition to alcohol. As the Great Depression grew worse, some prostitutes along T and U Streets ditched the speakeasies for a more unusual arrangement: they would meet their johns in a taxi and then split the fee with the driver. It eliminated rent while also reducing alcohol sales.

The cultural center of the U Street neighborhood was the Howard Theatre (620 T Street, Northwest), which opened in 1910 and was the preeminent black theater in the city; it could hold 1,500 people. It was white owned and black managed. The Howard closed for two years during the

Opened in 1910, the Howard Theatre was the premier entertainment venue for the black community. Closed in 1970 as the Shaw neighborhood declined, this 2011 photo shows it undergoing restoration. *Garrett Peck.*

Great Depression but reopened in grand style in 1931 with Duke Ellington beginning a three-week run. If you can think of a famous black performer of the twentieth century, chances are they performed at the Howard. As the neighborhood declined, the theater closed in 1970. As of 2011, the historic building is undergoing a $28 million restoration.

Next to the Howard was Frank Holliday's poolroom, where Duke Ellington hung out in his musically formative years. Born in Washington in 1899, Edward Kennedy Ellington began performing concerts by 1917, just as prohibition began in the district. He wrote in his autobiography:

> *Those were the days when I was a champion drinker. I was eighteen, nineteen, or twenty, and it was customary then to put a gallon of corn whiskey on the piano when the musicians began to play. There were four of us in the group, and one hour later the jug was empty. At the end of every hour the butler would replace the empty jug with another full gallon of twenty-one-year-old corn.*

The opening of the thirty-two-thousand-seat Griffith Stadium in 1912 at the eastern end of U Street, right below Howard University, began to change the street. White people began coming to the mostly black neighborhood to watch baseball. And as prohibition settled in, they came for jazz and bootleg cocktails as well. U Street had arrived as an entertainment destination.

The Lincoln Theatre (1215 U Street) opened in 1922 under black ownership. It sat next to the Minnehaha Theater (now Ben's Chili Bowl). Directly across the street was the Capitol City Club, a members-only club

that required a key to get in. Though the latter site has long since been redeveloped, members-only clubs were often a clear sign of a speakeasy—it was a way of screening out undercover police.

Built in 1908—President Theodore Roosevelt laid the cornerstone—the Twelfth Street YMCA (1816 Twelfth Street) was one of a handful of YMCAs in the nation that allowed African Americans to participate in athletic programs. It was here that basketball first took root in the city. Langston Hughes lived there while he wrote his first book of poetry. The building is now the Thurgood Marshall Center for Service and Heritage.

The Lincoln Theatre opened in 1922 next to the Minnehaha Theater, now Ben's Chili Bowl. *Garrett Peck.*

The True Reformer Building (1200 U Street) was built in 1903 as a community center. Today it's easy to spot with its huge mural of Duke Ellington on the side. In its heyday, it was popular for Saturday evening basketball games, followed by Duke Ellington–led dances.

While not as famous as Harlem's Jazz Age clubs, Washington certainly had its share of clubs and famed talent that performed on its stages. The Club Caverns (now the Bohemian Caverns, 2001 Eleventh Street, Northwest) opened in 1926. This is still one of the premier jazz clubs in the city. Likewise, Republic Gardens (1355 U Street) was a well-regarded live music venue.

The Caverns and Republic Gardens could each hold about one hundred people—intimate spaces where the artists are always approachable. As jazz got more popular, new clubs opened to handle the public's insatiable appetite. Chief among these was Club Bali (1901 Fourteenth Street), which could entertain up to three hundred guests. It was considered one of the finest jazz clubs in the city and hosted every jazz musician you can imagine, including Louis Armstrong and Ella Fitzgerald.

Opened as the Club Caverns in 1926 along U Street, the "Black Broadway," Bohemian Caverns is still one of the premier jazz clubs in Washington. *Garrett Peck.*

I can't cover every jazz club—there were quite a lot—but two others are worth mentioning. Club Bengasi (1423–25 U Street) was a popular destination. And Murray's Palace Casino (on the second floor of 922 U Street, Northwest) doubled as a dance hall. A very young Cab Calloway played there on January 12, 1933, as the end of prohibition was being discussed in Congress. Remember Calloway's electric performance singing "Minnie the Moocher" in the movie *The Blues Brothers?*

Were there speakeasies on U Street? Yes, they were probably everywhere. Most jazz clubs had a certain clandestine undercurrent—waiters could quietly sell a bottle or provide a highball in a coffee mug. Yet club owners had to be meticulously careful if they wanted to escape being raided or padlocked. If the Crusaders map from February 1932 is any indication, there was a large concentration of raided speakeasies in the less well-to-do black areas of Seventh and Ninth Streets but fewer busts along U Street (see page 138).

Right: A young Cab Calloway played at Murray's Palace Casino on January 12, 1933, in the waning days of prohibition. *Carl Van Vechten Collection, Prints and Photographs Division, Library of Congress.*

Below: The site of Murray's Palace Casino at 922 U Street, Northwest, in 2011. *Garrett Peck.*

TEMPERANCE AVENUE

As prosperous as U Street was for middle-class African Americans, there was a deep undercurrent of poverty literally just a block away on an alley known as Temperance Avenue, just north of T Street between Twelfth and Thirteenth Streets, Northwest. It was midway between the Twelfth Street YMCA and the True Reformer Building, the neighborhood landmarks.

Cities swelled with new black residents during the Great Migration. New York had the largest number of black people, followed by Washington. Those from the countryside found themselves on the bottom rung of society, the poorest of the poor. Alleys became homes for many.

Many Washington row houses had alleys behind them. Residents realized that they could turn this into revenue by converting part of their backyards or stables

along the alleys into rental units or by selling the property adjacent to the alley. Thus were born the alley dwellings. They first started developing during the Civil War when escaped slaves fled to the city and needed a place to live. An 1892 law required that alley dwellings only be built in alleys at least thirty feet wide and hooked up to sewage and water. Landlords rented to poor people, often to African Americans but also to working-class whites. In some cases, multiple families rented a single shack, effectively making them tenements. The alleys became slums, often with no heating, electricity or plumbing.

A 1912 report by the National Civic Federation revealed that there were sixteen thousand people living in alleys in the district. The conditions were notoriously unsanitary,

Many poor African Americans lived in alley dwellings, which were often just shacks without plumbing. This photo was taken in 1935 near the Cannon House Office Building. *Prints and Photographs Division, Library of Congress.*

and the report noted that "[o]ne-third of all alley babies, under one year of age, die. Tuberculosis finds its richest harvest in the alleys. In the alleys, vice rears its head unashamed and crime boldly flaunts itself." Rents were exorbitant. Congress created a Board for the Condemnation of Insanitary Buildings in 1906, and the board began to condemn individual properties that were deemed unsuitable for human habitation.

Led for years by Shiloh Baptist Church pastor Milton Waldron, the Alley Improvement Association was organized by African Americans to provide nurseries for working mothers, reduce the risk of tuberculosis and eventually move the inhabitants to more sanitary conditions. The association noted that bootlegging was rampant in many alleys and believed that clearing out the inhabitants would eradicate the problem. This is perhaps how Temperance Avenue got its name.

Temperance Avenue was occupied by poor African Americans who rented from middle-class black homeowners. The alley had twenty-six households totaling about 134 people, of whom a quarter were related, making it a tight-knit community that would watch out for children and provide for those going hungry. It was also an insular community, distrustful of outsiders and the police, who pried into their living conditions. It was not the largest or most densely populated alley dwelling, being only one block long. Its proximity to U Street made it remarkable in the contrast between the poverty in the alley and the wealth of the entertainment district just a block away—especially given that both streets were African American.

U Street historian Blair Ruble countered:

> *Rather than being the dens of iniquity that reformers believed them to be, alleys were play areas for children, outdoor laundries for women, refuges for men, and conversation pits for all. The informal social world of the alley sheltered inhabitants from the humiliation and hardships of the wealthier and whiter world beyond. Residents drifted in and out of the alley every day.*

President Woodrow Wilson's first wife, Ellen, championed alley relief, visiting them and encouraging Congress to provide funds to relocate residents to better homes. In 1914, shortly before Ellen's death, Congress passed the Alley Dwelling Act to convert the alleys into streets, but without funding replacement housing. With the World War I housing shortage, clearing alleys was put on hold. Eleanor Roosevelt would likewise champion the cause with the Alley Dwelling Elimination Act in 1934, though it took two more decades to finally move the residents.

Just a block from bustling U Street was a poor alley dwelling community known as Temperance Avenue, shown in 2011. The inhabitants were resettled in the 1950s. *Garrett Peck.*

The alley dwellings along Temperance Avenue were occupied until the mid-1950s. The dwellings deteriorated through landlord neglect, and the street had a reputation for crime, including petty theft, drug trafficking and prostitution. The city finally resettled the inhabitants—many in public housing, as urban renewal sought to clear the city of blight—but also uprooted established communities. Temperance Avenue was no more.

A 1937 Federal Writers' Project concluded despairingly:

> *The Negro of Washington has no voice in government, is economically proscribed, and segregated nearly as rigidly as in the southern cities he contemns. He may blind himself with pleasure seeking, with a specious self-sufficiency; he may point with pride to the record of achievement over grave odds. But just as the past was not without its honor, so the present is not without bitterness.*

It would be another generation before African Americans began making effective political gains in the nation's capital and the country through the civil rights movement.

Sixteen Awful Years

H.L. Mencken, the bard of Baltimore, called the Prohibition era the "Thirteen Awful Years." But prohibition lasted more than two years longer in Washington, D.C.—from November 1917 to March 1934—making these sixteen awful years. Mencken was one of the leading literary and social critics of the early twentieth century, a man of wide-ranging and hyperbolic opinions that he shared in his hilariously subversive essays. A man who enjoyed imbibing, Mencken stockpiled his basement with beer and booze before the Prohibition era began and then soon discovered that he could easily get resupplied because of the prevalence of bootleggers, who he referred to as "booticians."

Frederick Lewis Allen published his classic history *Only Yesterday: An Informal History of the 1920s* in 1931, when the events were still quite fresh. He penned a phenomenal chapter on prohibition called "Alcohol and Al Capone," declaring that the noble experiment was "the most violently explosive public issue of the nineteen-twenties." He wrote:

> *If you had been able to sketch for* [the average American citizen] *a picture of conditions as they were actually to be—rum-ships rolling in the sea outside the twelve-mile limit and transferring their cargoes of whisky by night to fast cabin cruisers, beer-running trucks being hijacked on the interurban boulevards by bandits with Thompson sub-machine guns, illicit stills turning out alcohol by the carload, the fashionable dinner party beginning with contraband cocktails as a matter of course, ladies and gentlemen undergoing scrutiny from behind the curtained grill of the speakeasy, and Alphonse Capone, multi-millionaire master of the Chicago bootleggers, driving through the streets in an armor-plated car with bulletproof windows—the innocent citizen's jaw would have dropped.*

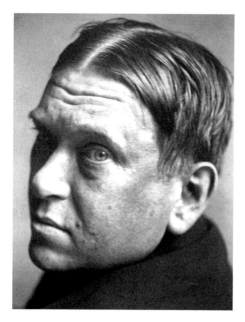

H.L. Mencken was America's most famous literary critic. He called prohibition "Thirteen Awful Years." Photograph by Robert Davis, 1928. *Courtesy of Enoch Pratt Free Library, Maryland's State Library Resource Center, Baltimore, Maryland.*

It wasn't supposed to be this way. The temperance movement had promised a dry utopia. The movement misunderstood American's desire to drink and never realized how many people would be offended by losing a civil liberty—the right to drink—or by American's willingness to break the law. Millions of law-abiding Americans became criminals. There was so much money to be made distilling spirits and selling them illegally. Many people set up stills in their homes and sold the bathtub gin to their neighborhood bootlegger. As Will Rogers said, "Prohibition is better than no liquor at all."

Author Sinclair Lewis moved to Washington, D.C., in 1916. He had the pulse of the times better than almost anyone and understood Americans' willingness to disobey prohibition—while pointing out their hypocrisies. In the novel *Babbitt* (1922), the hero, George Babbitt, shares a bottle of gin with several others on a train journey. The man who provided the gin stated, "I don't know how you fellows feel about Prohibition, but the way it strikes me is that it's a mighty beneficial thing for the poor zob that hasn't got any will-power but for fellows like us, it's an infringement of personal liberty." Right there Lewis captured why prohibition was destined to fail: everyone made

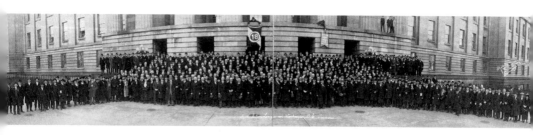

A panoramic photograph, taken on December 8, 1921, of the Anti-Saloon League convention held in Washington. *Prints and Photographs Division, Library of Congress.*

an exception for themselves. Prohibition was for others to obey, but not me.

Lewis lived at a number of residences in the Dupont Circle neighborhood, including 1814 Sixteenth Street, Northwest, from 1919 to 1920 while he wrote *Main Street* (1920) and at 1639 Nineteenth Street, Northwest, where he wrote *Babbitt* (1922). These two novels were critically acclaimed and won major commercial success for Lewis (he won the Pulitzer for the former and a Nobel prize for the latter).

Women who had never set foot in a saloon before began stepping into the speakeasy. Drinking was illegal for everyone, so women were equally breaking the law with men. Disobeying the law became glamorous, and the hip

Author Sinclair Lewis had his finger on the pulse of the American mood better than almost anyone. He wrote his Nobel Prize–winning novel *Babbitt* at this Dupont Circle house in 1922. *Garrett Peck.*

flask became the new status symbol of rugged individualism and urban chic.

The 1920s was a profoundly different decade. The Progressive Era was over, people were tired of the government trying to perfect society and consumerism ran wild as household appliances were all the rage. People bought radios and cars. This being the era of Sigmund Freud, people started seeing their shrinks and talking frankly about sex. The 1920s was the country's first sexual revolution, predating the more famous one by four decades. And women were socially equal now that they had the vote.

The National Liberal Alliance, an organization of young women, came to Washington in January 1923 to survey what district residents really thought of dry law. The organization was the polar opposite of the Anti-Saloon League. Thus far the group had polled about 3,000,000 people in New England and New York, and now it was Washington's turn. The poll asked people if they wanted to see a return of beer and light wines. The result was

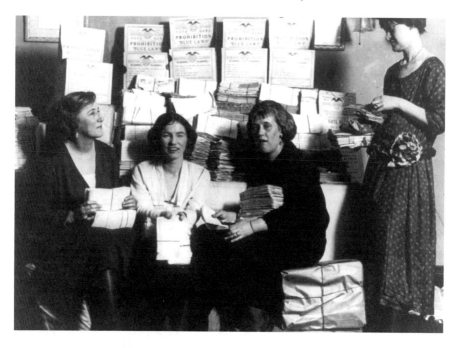

Above: The National Liberal Alliance surveyed district residents about dry law in January 1923. The result was lopsided: 55,876 voted wet, while 1,398 voted dry. Young women counted the ballots. *Prints and Photographs Division, Library of Congress.*

Left: Women earned the right to vote in 1920, and since drinking was now illegal for everyone, women joined men at the speakeasy to equally break the law. *Prints and Photographs Division, Library of Congress.*

quite lopsided: 55,876 people voted wet, while 1,398 voted dry. Since district voters never got to vote on prohibition—Congress had made the decision for them—this was the only dry referendum the city would ever get.

An Anti-Saloon League member named Delcevare King of Quincy, Massachusetts, grew tired of the disregard for the law of the land—especially after hearing about the drinking at his alma mater, Harvard. In 1923, he sponsored a nationwide contest to invent a word that would best describe these lawless drinkers. The prize of $200 was announced on January 16, 1924, in the *Boston Herald*. It went to two people who came up with the word "scofflaw." The term was soon widely adopted—in part by the violators themselves—and just a week later Harry's Bar in Paris invented the Scofflaw cocktail, one of the genuine cocktails that came from the Prohibition era (see the recipe on page 114).

Temperance advocates realized that they would have to be ever vigilant, as they witnessed widespread lawbreaking. The Methodist Board of Temperance, Prohibition and Public Morals, a key ally for the Anti-Saloon League, put up a new building at a prominent Capitol Hill address in 1923. The board members chose the site well. The United Methodist Building (100 Maryland Avenue, Northeast) is located directly across the street from both the U.S. Capitol and the U.S. Supreme Court. It served to remind Congress that prohibition was the government's duty to enforce. (The U.S. Supreme Court Building wasn't built until 1935, after prohibition had ended.) The

The United Methodist Building directly faces the U.S. Capitol. It was built in 1923 for the Methodist Board of Temperance, Prohibition and Public Morals and to remind Congress that prohibition was the rule of the land. *Garrett Peck.*

building included a number of apartments, which Congressional allies rented while they were in town. The board added a five-story wing in the early 1930s that more than doubled the size of the building. By the 1950s, the country had moved on from the Prohibition era, and as the leaders of the temperance movement died off, the board was disbanded. The building now houses the United Methodist General Board of Church and Society, as well as a number of ecumenical organizations.

Investigative reporter Walter Liggett wrote damningly about Washington's drinking scene in 1929: "I find that considerably more persons are engaged in the liquor traffic now than in the days of the open saloon; that liquor is available in more places than when its sale was legal; that the consumption of hard liquor has increased." Crime hadn't disappeared, nor had the poverty-stricken slums, despite the ardent promise of the drys. Arrests for intoxication and crime had virtually doubled from pre-Prohibition years, indicating how much worse the problem had become—especially among minors. Liggett concluded that "[t]he brutal, unvarnished truth is that today there is vastly more drunkenness, juvenile delinquency, crime and poverty than in the days when saloons ran openly in the District."

ENFORCING PROHIBITION

The federal government was unprepared for the great wave of crime from prohibition. The temperance movement had simply assumed that people would obey the law, and the Volstead Act was seriously underfunded. But there was so much money to be made in alcohol. Countless public figures and policemen were bribed. In many cities like New York and Chicago, prohibition was unenforceable.

Wayne Wheeler, responding in a 1925 *Washington Post* op-ed, put the cart before the horse. He claimed that the saloon was the headquarters of organized crime and that prohibition revealed this criminality rather than magnified it. Wheeler's argument was Orwellian:

> *Prohibition has not been the cause of these evils, but it has revealed and reduced them. They are the resultant of the liquor traffic which was licensed in this country for over half a century. It is significant that in many of the cities many gunmen and underworld characters were never brought to justice until the saloon, their headquarters, was outlawed.*

In fact, most saloon owners had been law-abiding citizens rather than organized criminals. And some cities, like Washington, had no organized crime—just a lot of entrepreneurs who had spotted a business opportunity.

Enforcing prohibition in the district was constant work, but it also came in waves as politicians put pressure on law enforcement to do something about the problem. After the 1919 race riot, Congress appropriated funds to increase the size of the Washington Metropolitan Police Department by 300 people. The force had 1,000 people on its rolls to protect and serve the citizens of the nation's capital. Only a small fraction, 28 men, was dedicated to enforcing prohibition, but it was a fairly effective team, one that largely remained free of corruption. There just weren't enough of them to adequately shut down the liquor traffic.

The MPD had a "flying squad" of four people under Sergeant George Little whose job it was to chase after bootleggers in automobiles. They were also deputized federal revenue agents, which gave them authority to chase bootleggers into Maryland or Virginia and arrest them. Even with several hundred arrests each year, there were too many roads leading into the city for Little's squad to catch more than a small fraction of rumrunners. A separate twenty-man vice squad, first under Sergeant Oscar Letterman and then under Sergeant J.R. Leach, went undercover to find people selling

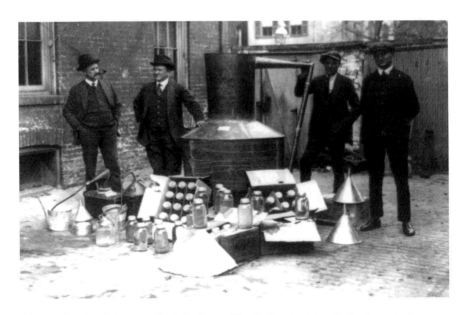

A November 1922 photograph of the largest illegal still seized thus far in the nation's capital. *Prints and Photographs Division, Library of Congress.*

alcohol and then conducted raids after getting a search warrant, often in conjunction with a Prohibition Bureau agent. These same detectives also had to root out the city's gambling parlors, which were nearly as prevalent as speakeasies and just as illegal. Only these twenty-eight men were allowed to make arrests for Volstead Act violations.

Washington had a string of seven police superintendents during the Prohibition era. The liquor question drew little public notice until the mid-1920s, when it became clear that dry law was widely ignored in the nation's capital. Major Edwin Hesse, who served from October 1925, was at the fore of much of this attention. He noted how speakeasies simply reopened after being raided. He called for them to be padlocked, a tactic that had worked successfully in New York, as well as for violations to be charged as felonies rather than as misdemeanors. This would obviate the need for a search warrant.

Hesse was removed from office in April 1929, just one month after President Herbert Hoover's inauguration, after admitting that prohibition was getting more difficult to enforce. The Anti-Saloon League insisted that only absolutely committed dry men should hold positions of responsibility. Major Henry Pratt replaced Hesse until he, too, was replaced in November 1931. Pelham Glassford served less than a year, followed by Major Ernest Brown in October 1932 in the waning days of prohibition.

BOOTLEGGING

We should differentiate bootleggers from speakeasies. Bootleggers were people who transported liquor into the city or people who would sell a pint of liquor on the street, in an alley or, in George Cassiday's case, in the halls of Congress. Speakeasies were clandestine saloons, often hidden in plain sight. You often had to know someone to get in. Both kinds of businesses operated with great success in Washington.

Collier's Weekly magazine published the anecdotal but insightful article "Bartender's Guide to Washington" on February 16, 1929—just two days after the Valentine's Day Massacre in Chicago. It began: "Somehow, it doesn't seem right. Of all cities, Washington, where all the prohibition laws are passed and millions of dollars appropriated to exterminate the liquor traffic—well, Washington ought to be dry. But shucks. The city's so wet that it squishes."

The author, Walter Davenport, admired that Washington had avoided the Mafia turf wars and violence of other large cities. There was no organized

crime but rather many small players who served the thirsty public. "But you'll meet the politest and gentlest of bootleggers. No rough stuff. No racketeering. Quiet, prompt service and plenty of it. That's Washington."

It seemed that anybody could be a bootlegger. Amateurs dominated the market. Davenport reported: "Bootlegging was in the hands of Negroes, young government clerks, former prohibition enforcement officers who had been fetched to Washington to be fired, young ladies with bright social flares and roomy apartments and a wide variety of nondescripts of all ages who dealt almost exclusively in bathtub gin." As there was so much competition, prices could be all over the map, but it was generally pretty inexpensive to get a drink.

Journalist Walter Liggett published an insightful article in the *Plain Talk* in December 1929 called "How Wet Is Washington?" His answer: wringing wet. He calculated that 6,000 gallons of redistilled alcohol, 9,000 gallons of Virginia corn whiskey or Maryland rye, 7,000 gallons of distilled spirits produced in the district and 1,000 gallons of medicinal liquor were being imported each week into Washington. When cut with water to make "bathtub gin," that came to 1.6 million gallons, or the same amount of spirits consumed before prohibition. Many citizens were home-brewing beer nearing pre-prohibition levels. In other words, Washington was just as wet during prohibition as before.

Liggett counted about 4,000 bootleggers in the city (2,500 were white men, 500 were women and 1,000 were black). He noted that bootleggers often made home deliveries—you didn't need a speakeasy to wet your whistle, only a phone number.

The *Washington Post* wittily noted, "The effects of bootleg liquor are such that it can no longer be accurately described as speakeasy." Many bootleggers were unscrupulous, using unnatural or tainted ingredients such as denatured or wood alcohol. H.L. Mencken wrote cynically that "Prohibition, as everyone knows, has not materially diminished the consumption of alcohol in the cities, but it has obviously forced the city man to drink decoctions that he would have spurned in the old days—that is, has forced him to drink such dreadful stuff as the farmer has always drunk." You never knew what you'd buy from a bootlegger. Will Rogers wrote, "One thing to be said for it, prohibition will work if you drink it," meaning you wouldn't want another drink after sampling rough hooch.

Reporter Edward Folliard was amazed by how brazen bootleggers could be. Early in the Prohibition era, they sold booze at the southwest corner of Fourteenth and E Streets, directly across from the District (Wilson) Building, which was police headquarters. Others hid their stash in the bushes around the White House.

Bootleggers took advantage of a key piece of technology that was reaching the masses in the 1920s: the automobile. The car served as a way to transport the product to market and also as a fast getaway in case of pursuit. Some bootleggers used multiple cars as decoys to lessen the chance of getting caught; others installed smoke screen devices that could blind pursuing police. Cars would sometimes be hijacked by people who thought that they were carrying illicit hooch. A popular sign appeared for sale at drugstores, alerting potential hijackers that the car was liquor-free.

There were many hot pursuits across the district, but few captured the attention as much as a wild chase on January 21, 1922. Tipped off that a car loaded with booze was headed from Alexandria, Virginia, to the district, the police arrived at the Fourteenth Street Bridge just as the bootleggers literally crashed into them. The bootleggers raced north past the Wilson Building as the police opened fire, and the bootleggers shot back. All told, about thirty shots were exchanged, which was especially dangerous because this was during the lunch hour and the sidewalks were crowded with people. The bootleggers desperately made for the Maryland border, racing across downtown and even careening onto sidewalks, injuring several bystanders. The car finally crashed into a coal truck at Fifth and O Streets, Northwest. One occupant fled on foot, but the other two, Donald Kane and fifteen-year-old Elmer Ardusen, were arrested. Kane already had a prior record for assault with a deadly weapon and was on probation; he was immediately sent to the Leavenworth penitentiary.

Prohibition Bureau agents seized 749 cases of beer that were being transported from a Philadelphia brewery to Washington. The judge

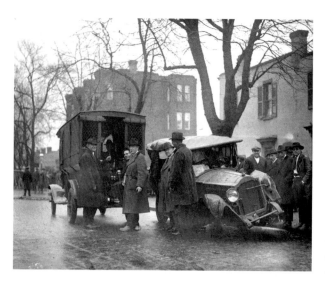

On January 21, 1922, three bootleggers led the police on a thrilling car chase through downtown Washington before crashing into a coal truck. *Prints and Photographs Division, Library of Congress.*

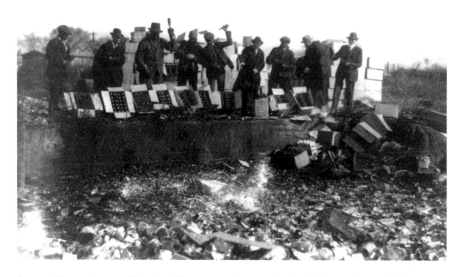

Some eighteen thousand bottles of beer were destroyed at the Arlington dump in November 1923 after agents seized the illegal shipment bound for Washington from a Philadelphia brewery. *Prints and Photographs Division, Library of Congress.*

overseeing the case ordered the beer destroyed. Agents smashed eighteen thousand bottles—one at a time—in November 1923 at the Arlington dump.

Little violence permeated Washington from prohibition, but there was always an exception. On February 15, 1924, Vermont senator Frank L. Greene was walking with his wife along Pennsylvania Avenue between Third Street and John Marshall Place, Northwest, returning to the Driscoll Hotel, where they lived, next to the Anti-Saloon League's local office. Two policemen and a Prohibition Bureau agent came across three bootleggers who were apparently unloading a still from a car in an alley. The agent, Otis Fisher, drew his gun and gave chase; the three bootleggers opened fire, jumped in the car and roared down the alley. Fisher fired four shots at them, disregarding the pedestrians walking along the Avenue. Senator Greene was severely wounded in the head by one of Agent Fisher's shots. He and his wife were at the wrong place at the wrong time. Greene survived but would only live another six years.

The Navy Yard was one of the largest employers in the city, and there were plenty of people who supplied the sailors and contractors with alcohol. There was a large cluster of speakeasies in the neighborhood surrounding the Navy Yard. One of the more interesting busts came from the arrest of two female nurses stationed there, Ruth Anderson and

Washington largely escaped the gangland violence of other American cities during prohibition. However, Vermont senator Frank Greene was caught in a crossfire between bootleggers and Prohibition Bureau agents and was severely wounded. *Prints and Photographs Division, Library of Congress.*

Katherine Glancy. Customs agents had found a large quantity of distilled spirits in their luggage when they were reassigned from Guantanamo Bay, Cuba, to Washington. Secretary of the Navy Curtis Wilbur ordered the two women court-martialed for smuggling. Their acquittal was certain from the beginning, as naval officers frowned on bringing sailors on charges for possession (the custom was simply to confiscate liquor if found). The two nurses simply pled that the bottles had been given to them as a farewell present but that they didn't know it was liquor. Anderson's supervisor was asked about the defendant's "temperance." She dodged the question by answering, "She is not temperamental at all." The two nurses were quickly exonerated on June 17, 1925, after what was, essentially, a show trial. The *Washington Post* reported that the trial "proved enjoyable, bordering on hilarity for everyone except the accused."

Assistant attorney general Mabel Walker Willebrandt noted that Washington had long been supplied by moonshiners from Maryland and Virginia. Agents sometimes intercepted these shipments. She commented, "Most people, unfamiliar with the liquor history of the national Capital, would naturally view such seizures as the direct outgrowth of the prohibition law. Such is not the case, however. Ready market for tax-free liquor has always existed in the metropolitan centers of Baltimore and Washington." In other words, there had long existed suppliers and a market for bootleggers in the mid-Atlantic.

The state at Washington's northern border is Maryland, which was known as the Free State not for religious liberty but because the state never passed a

How Dry We Weren't

Two navy nurses, Ruth Anderson (left) and Katherine Glancy (right), were court-martialed in June 1925 at the Washington Navy Yard for smuggling liquor into the country. They were quickly acquitted. *Prints and Photographs Division, Library of Congress.*

Police Officer Herbert Glassman was cited for bravery during the 1919 race riots. Ten years later, he was busted for leading the city's largest liquor ring out of a rental car agency. *Prints and Photographs Division, Library of Congress.*

prohibition enforcement act. Liquor flowed freely over the Maryland border into Washington. Baltimore became a major distribution point. This was where the largest liquor ring in the nation's capital, run by Herbert Glassman, bought its supply. It trucked in at least a thousand gallons of booze from Charm City each week. Glass ran a rental car agency with garages at 2101 Fourteenth Street, Northwest, and 1319 L Street, Northwest. Federal agents broke apart the liquor ring, arresting a dozen people on August 15, 1929, and seizing a large quantity of whiskey. The ring was notable for Glassman, who was a former policeman in the Metropolitan Police and had been cited for bravery during the 1919 race riot.

The government padlocked the two Glassman Rent-a-Car garages. As the courts were overwhelmed, the ring finally went to trial in February 1931. Nine men were convicted of violating the Volstead Act. Glassman and two others were sentenced to two years in jail and fined $5,000 apiece. The other defendants went to jail for eighteen months.

SPEAKEASY, FRIEND

Probably the most frequent question I get leading a Temperance Tour is, "Where were the speakeasies?" The answer is everywhere. The city was crowded with them (see the Crusader map on page 138, and you'll see what I mean). That said, it is quite difficult to visit an actual speakeasy. Most of the sites were private homes. Many locations were downtown, and as Washington was redeveloped, these succumbed to the wrecking ball. We are far more likely to find extant speakeasy locations in residential neighborhoods like Dupont Circle and Capitol Hill.

George Rothwell Brown, a *Washington Post* columnist who published a history of Washington in 1930, estimated that the city had about 3,000 speakeasies during the Prohibition era. Walter Liggett conservatively counted 650 speakeasies (most commentators agreed that there were 2,000 to 3,000 speakeasies). Of these, 200 were for African Americans in Southeast and Southwest, 300 were scattered across the city and 150 were "beer-flats," expensive apartments where women offered drinks. There were also hundreds of social clubs that required membership to enter—and this helped protect them against police raids.

The *Washington Post* ran an exposé in November 1928 on the development of speakeasies in the city. "Now, anyone who knows the ropes may go almost anywhere in the downtown section and get liquor, served in little back rooms,"

How Dry We Weren't

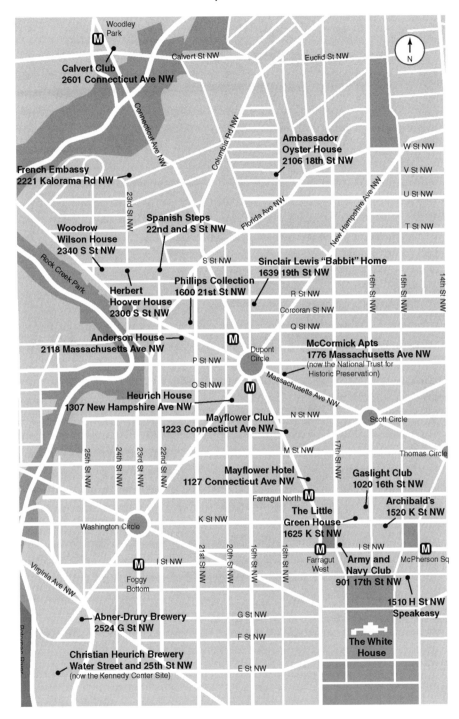

A map of Dupont Circle, Kalorama and Foggy Bottom. *Kenneth P. Allen, mapmaker.*

wrote the reporter. You could throw a rock from the National Press Club and hit several speakeasies. There were swanky joints close to the Mayflower Hotel for swanky customers. A visitor arriving at Union Station needn't walk far to wet his whistle, and a senator could have a drink right under the dome of the U.S. Capitol. "Here is the Nation's Capital—where they made the law. Here, in little back rooms, men gather and violate the law."

The correspondent also tested the purported liquor for authenticity. The speakeasies claimed that their stuff was real Canadian Club whisky, gin or Scotch. Not a bit of it was the real deal; though chemically safe to drink, all of it was synthetic. Prices for a drink ran a few cents for rotgut liquor near the waterfront to as much as one dollar for a highball in more fashionable neighborhoods. The reporter wrote insightfully, "Reformers will say this is a deplorable condition. Those who are against reformers, tooth and nail, will say, too, that this is a deplorable condition—that speak-easies should be a necessary evil; but men, they will tell you, want what they want when they want it. Hence, the speak-easy."

Collier's noted that Washington developed its own unique establishments and traditions for drinking. "The night club as it flourishes in New York has no existence in Washington, but its place is more than adequately filled by the social club," witnessed the author, Walter Davenport. Social clubs were private and required membership, but it was easy to find one to join. Davenport visited one called the HBQ Social Club on P Street. Opened in a four-story building, the ground floor had a dry cleaner, the second floor had dancing, the third floor was for drinking and the top floor offered gambling.

Speakeasies seldom kept liquor in the room where the customers drank. Instead, they kept it locked in a back room, where they could quickly pour the evidence down the drain if necessary. This was a precaution against police raids—they never wanted to have too much of their product exposed for confiscation. Davenport noted that places like HBQ offered drinks called a "set-up." They would provide a glass filled with ice and a bottle of soda water or ginger ale. "No liquor is sold by the club," Davenport noted, "but you have only to let it be known that you are in the market for a bottle or so when a man appears with the tidings that he can fetch you gin, whisky or cognac in a few minutes, or wine." He noted that the club's windows were screened and locked.

Some social clubs or speakeasies were under police surveillance, and a policeman guarding the door might take down patrons' names as they entered. In an era before photographic identification, it was easy enough to provide an alias. The police also had to be careful in arresting someone with powerful patronage, like a congressman, as this could end the policeman's career.

How Dry We Weren't

Collier's Walter Davenport didn't think too highly of the speakeasies he found during his investigation: "The Washington speakeasy suffers by comparison with its New York, Chicago, Boston, St. Louis, Detroit and even Baltimore brother. Not that they are not numerous enough but one must crave a drink with considerable desperation to make a habit of them." Drinks went for fifty cents a shot, often in tawdry places like the back of laundries and lunchrooms. He noted that beer was incredibly difficult to find, though it was easy enough to find bathtub gin or Maryland rye. Much of the drinking occurred out of public sight, underground or in homes. "There is much entertaining and counter-entertaining. It is contended, and one is moved to accept it as highly probable, that most of the District's drinking is done within the home, within the clubs, at social functions variously."

In this chapter, we can't cover every speakeasy raid—there were thousands of them alone in Washington—but we can cover some of the juicier stories. Let's begin with a virtual tour of Washington's speakeasies.

One of the first speakeasy images of Washington comes to us from the Library of Congress. On April 25, 1923, Prohibition Bureau agents and police raided Carl Hammel's lunchroom at 922 Pennsylvania Avenue, Northwest, seizing barrels of liquor stored in the basement. He had converted his former saloon into a restaurant but continued the trade in a little back room. This site was later redeveloped in what is now the Federal Triangle.

A grand jury indicted thirty-six people in three high-profile busts in Washington in early 1924: William and Helen Simpson, prominent caterers who had arranged to serve liquor at a private dinner; a large liquor ring that resulted in dozens of Volstead Act violations; and police lieutenant Joshua Sprinkle, several U.S. marshals and a liquor ring that these law enforcers were allegedly protecting.

The Gaslight Club (1020 Sixteenth Street, Northwest) was a prominent social club headed by retired rear admiral Bob Archer. Apparently, it was also home to a speakeasy on its third floor, as federal agents raided the club on the morning of March 4, 1925, inauguration day for Calvin Coolidge. Archer was arrested along with twenty-five others, including senior government officials, diplomats and well-known journalists. The speakeasy itself was cleverly disguised—you reached it through the men's room. Patrons turned a faucet handle, and that opened a secret door into the speak. Drinks were served in navy mugs rather than cocktail glasses. The club's manager, who was not arrested, remarked rather disingenuously to the *Washington Star*, "Why, I've used that men's room a hundred times, and never knew there was anything but an unused storeroom in back of it." He must have never washed his hands.

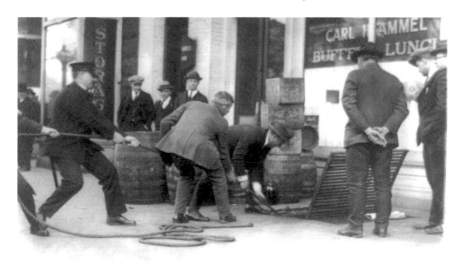

A 1923 photo of lunchroom raid. There were up to three thousand speakeasies in the nation's capital. *Prints and Photographs Division, Library of Congress.*

The downtown strip club, Archibald's Gentlemen's Club (1520 K Street, Northwest), had a speakeasy on its third floor, run by a young African American out of his apartment living room. The location sits prominently on K Street, home to myriad law and public relations firms. It had a front company: Tyler and Rutherford, loan correspondents for the Mutual Benefit Life Insurance Company. This was a fairly common front for illicit booze sellers. Just imagine. This was once how K Street and much of Washington looked: a street of short, narrow, brick town houses. Much of that has been torn down and replaced by larger office buildings, but Archibald's survives. It is indeed a strip club today and has been since 1969, so probably not the best place to take the kids.

Just a block to the west, at 1625 K Street, Northwest, is the Commonwealth Building. That was once the site of the Little Green House, where President Warren Harding's Ohio Gang cooked up the Teapot Dome and other scandals to raid the national treasury.

The two most famous Prohibition Bureau agents were Izzy (Isadore) Einstein and Moe Smith. Frederick Lewis Allen wrote in *Only Yesterday* (1931) that the two were "prohibition agents extraordinary, putting on a series of comic-opera disguises to effect miraculous captures of bootleggers." The

Archibald's Gentlemen's Club, opened in 1969 as a strip club, was a speakeasy during prohibition that was masked as a mortgage agency. Much of K Street was once two- and three-story brick houses. *Garrett Peck.*

two did much of their work in New York, but the bureau sent them on field trips to other troublesome cities to pinch bootleggers and speakeasies.

Izzy even made a bust in Washington, as he wrote in his entertaining memoirs published in 1932: "In Washington it was a whole hour after I arrived there before I could succeed in buying liquor. But Baltimore was a cinch. All I had to do was get on a street car and ask the conductor to let me off at a place where I could get a drink. He pointed one out to me almost the first block. And I got the drink." He provided no further details about where he landed his catch in the district. Izzy never carried a gun, yet in his five years working for the Prohibition Bureau, he arrested 4,932 people—and dedicated the book to them.

On Capitol Hill, residents around Lincoln Park complained about the noise from the many speakeasies in 1926, as well as that the police were guarding the speakeasies rather than shutting them down. One resident complained, "The police arrest the drunks, but they don't make any attempt to check the source of this illicit supply of liquor."

One of the city's landmark dive restaurants is Tune Inn on Capitol Hill (331½ Pennsylvania Avenue, Southeast), which opened in 1947. The

The popular Capitol Hill dive bar Tune Inn was a candy store that illegally sold liquor during prohibition. *Garrett Peck.*

bar walls are covered with taxidermied animals and funny signs, and the clientele lack any pretense. Flannel shirts and Bud Light with a shot of whiskey are staples. The dive was a candy store during the Prohibition era, but that was a cover for a speakeasy. Below the bar was a small opening that led to the basement; one bottle at a time was brought up to the bar. Once prohibition ended, the bar claims, it got the second liquor license in the city.

A sensational case that seized the public's attention began with a raid on the Ambassador Oyster House (2106 Eighteenth Street, Northwest, in Adams Morgan) on August 3, 1928. A bystander, Earl Rickert, alleged that the police pulled him into the joint after he and a small crowd booed the raiders for demolishing the speakeasy; he also claimed that deputy prohibition commissioner John Quinn and a police detective beat him. It took three trials for a jury to convict the defendants, Clarence Myers and brothers William and Francis Deegan, in February 1929.

As people sensed that the noble experiment was coming to an end, club owners invested significantly in building grand speakeasies that would attract wealthier clientele—especially after Prohibition Bureau director Amos Woodcock shifted his attention away from speakeasies over to wholesalers in March 1933. Speakeasies in Washington breathed a sigh of relief. But that didn't mean that they were in the clear—the police continued their enforcement efforts.

One of the more unusual speakeasies was a houseboat that served its patrons while out on the Potomac River. It had operated for years without being caught—until two police rowed out, disguised as customers, in August 1933.

A downtown location, 817 Thirteenth Street, Northwest, was busted in August 1933. The *Washington Post* called it "Washington's most elaborate speakeasy." An eight-foot door lined with a thick steel plate guarded this second-floor location. After plainclothes police bought liquor there, a squad of ten men arrived with a search warrant. They arrested three employees but allowed the dozen customers to leave. The speakeasy reopened, and the police returned in November. This time they threw owner Jack Ahearn in jail for ten months. Speakeasy owners proved resilient, simply reopening their bars after a raid.

That wasn't the only prominent speakeasy raided in late 1933. One of the more prominent speakeasies was the Mayflower Club (1223 Connecticut Avenue, just south of Dupont Circle), which seemed to take its name from

The Mayflower Club was a swanky speakeasy and casino on Connecticut Avenue that was repeatedly raided just prior to prohibition's end. *Garrett Peck.*

the elegant Mayflower Hotel down the street. It offered high-end cocktails at its thirty-foot-long bar and gambling on the fourth floor of the building. This was a high-society joint with two-dozen tables, a printed menu of cocktails and a mural of Gandhi playing the piano with other notables. The police raided the place in summer 1933 but found no evidence. They returned on Friday, November 3, and hit the jackpot. Proprietor Zachariah "Zebbie" Goldsmith and a black porter, Robert Williams, were arrested, and a sizable quantity of high-end hooch was seized.

Both owners of these prominent speakeasies, Jack Ahearn of 817 Thirteenth Street and Zebbie Goldsmith of the Mayflower Club, pleaded innocent and demanded trials by jury. Their day in court arrived on December 13—eight days after repeal; however, Goldsmith's attorney got the charges dismissed, as did a score of other defendants, since prohibition had ended the week before.

That wasn't the end of the Mayflower Club. On February 18, 1934, the police vice squad returned once again and found a brisk business. They arrested Goldsmith yet again—despite protests that he no longer owned the club—and threw him and four other defendants before a grand jury on charges of failing to pay federal liquor taxes and allowing gambling. Besides seizing the liquor, the police ensured that the Mayflower Club would never open again: they demolished the place. Goldsmith's investment was destroyed.

Repeal didn't end speakeasy raids in the district, as the Sheppard Act still mandated that the city remain dry. On December 10, five days after prohibition ended, police raided the Calvert Club (2601 Connecticut Avenue). The site was formerly the El Salvador Legation. Four employees were arrested, but in the tradition of not exacerbating the public, the customers (including a number of women) were simply shown the door.

HIGH SOCIETY AND EMBASSY LIQUOR

Prohibition affected every strata of Washington society, from the poorest alley dwellers to the richest denizens.

Ambassador Larz Anderson III and his wife, Isabel Weld Perkins, built the Gilded Age Anderson House (2118 Massachusetts Avenue, Northwest) in Kalorama from 1902 to 1905. It cost almost $800,000 to erect and lavishly furnish the enormous house. The mansion was built not only for accommodations but also, above all, to entertain. A grand hall lined with

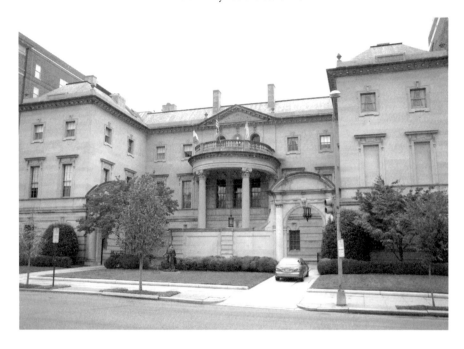

Above: Larz and Isabel Anderson built this lavish Kalorama house in 1905 as a place to entertain during the four-month high society "season." Larz had a poor opinion of prohibition and stockpiled the wine cellar to see them through the dry years. *Garrett Peck.*

Right: Larz and Isabel Anderson were one of the richest couples in America. They found the Prohibition-era social scene in Washington dull and full of hypocrisy. *Reproduced by permission of the Society of the Cincinnati, Washington, D.C.*

Belgian tapestries was popular for pre-dinner cocktails, the dining room table could comfortably seat forty people and the house even had its own ballroom. It took a forty-person staff to maintain the house.

The Andersons could afford such luxuries. Each came from spectacularly wealthy families. Their marriage combined two family fortunes into one: Larz had descended from a Revolutionary War officer and thus was a member of the Society of the Cincinnati, and Isabel came from a line of shipping magnates. She was said to be the richest women in America. This was a couple who knew their place in society—at the top. The Andersons were part of America's unofficial aristocracy.

Anderson had an elite education—Phillips Exeter Academy, Harvard University and Harvard Law School—before entering the diplomatic service in 1891. He served in London and Rome, volunteered as an officer in the Spanish-American War, was dispatched to the diplomatic corps in Brussels and finally served as ambassador to Tokyo, the capstone of his career, under President William Howard Taft. A committed Republican, Anderson resigned from the State Department rather than serve under Woodrow Wilson, the Democrat who won the presidency in 1912. Ironically, Wilson retired to a home just a few blocks away from the Anderson House.

The Andersons adopted a Gilded Age tradition popular among the nation's superwealthy: they came to Washington four months of the year during the annual high society "season" that ran from New Year's to Easter, coinciding with the return of Congress. They came to see and be seen—and to lobby for their interests. Much of the year, the Andersons

Larz Anderson was a talented sketch artist who knew that no camping trip was complete without Champagne. *Reproduced by permission of the Society of the Cincinnati, Washington, D.C.*

PROHIBITION IN MAINE

ONE - ARMED BARKEEP.

Larz Anderson
sketched this one-
armed bartender
on a trip to Maine.
*Reproduced by permission
of the Society of the
Cincinnati, Washington,
D.C.*

spent traveling in their private rail car or resided at their home in Brookline, Massachusetts.

In 1937, the year of Larz's death, Isabel gave the Anderson House to the Society of the Cincinnati as its permanent headquarters, library and museum. The house has archives on Prohibition-era material, including Anderson's extensive journals, all of them typed (not handwritten). He had a talented hand at sketching. On a camping trip to Maine, Anderson sketched a picture of the "necessaries" that accompanied the trip: boxes of Champagne and Sauternes.

The Andersons were no fans of prohibition. They apparently had no trouble buying high-quality hooch; his diaries are full of references to the cocktail hour. But Anderson complained in his 1924 journal that Washington society just wasn't the same since prohibition began:

> *Social life was more and more changed in Washington—prohibition cast its blight—there were fewer cocktail parties (they proved too severe) but there was something to drink at all the dinners we went to (for we had accepted with discretion—as official and semi-official and social dinners that are dry are not worth the while—no matter what company one meets—and at such dinners the company is generally made up of hypocrites).*

Before prohibition began, the Andersons had stocked the wine cellar in their Washington mansion. They were active entertainers, so it must have been a large stockpile indeed (the wine cellar is now part of the library in the

basement). Even in 1929, the supply of wine from the cellar hadn't run out, as Larz noted in his journal:

> *And from our cellars I served wine as I had always done, even with officials present I would not insult any other guests by having it seem I couldn't trust them to be decent. I had pre-war liquors and wines, in our cellars before even prohibition (before even the District was dried up) to serve with perfect legality when officials were present: and I still left unopened a cellar of pre-war wines for future use. I may add that all of the officials behaved perfectly decently in the presence of the wines.*

After more than a decade of entertaining under dry law, Larz finally despaired of having to entertain dry guests—or go to dry parties. He swore in 1929 that he had enough:

> *But these dinners and occasions were probably the last general parties which we shall ever give: I do not plan in the future either to accept invitations to any of these deadly dry parties of officials (except the White House if we should be included there as we have by every President for years) so that I may not feel under any obligation to invite them to my house. In the future I hope only to have people who know how to live and let live—to meet only those who entertain in a reasonable way: the Diplomats and old Washingtonians.*

Obviously to Anderson, entertaining "in a reasonable way" required good wine and cocktails. Embassies were technically foreign territory, so they could import alcoholic beverages. This kept alive at least some of the classic tradition of the Washington cocktail party, even during the Prohibition era, thanks to this loophole. "The Embassies and Foreign Missions are the only bulwark because they can serve wine—and there can be no real social life of importance or distinction without the serving of wine," noted Anderson in 1930.

Embassy liquor was a prohibition loophole that was specific to Washington. This led to widespread abuse—not by diplomatic staff, but by bootleggers who took advantage of the embassies' reputation. Most of the liquor that bootleggers claimed was "embassy stuff," in fact, wasn't. One clever bootlegger even got an inside man at an embassy, an African American named Waldron Lee, to bring him the empty bottles, complete with their labels, so he could fill them with whatever hooch might be passable. Little genuine embassy liquor made it into the market.

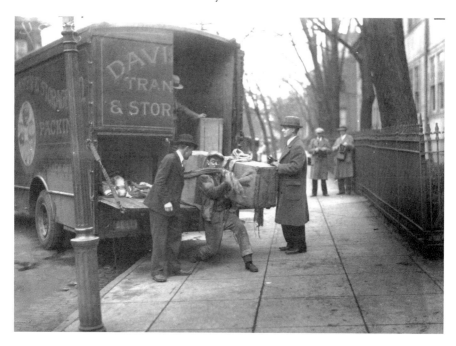

Embassies were foreign territory and so not constrained by prohibition. The British Embassy here takes a delivery of cases of liquor. *D.C. Public Library, Washingtoniana Division, Collection of Hugh Miller.*

Congress repeatedly threatened to shut down the embassy liquor loophole but never did. In 1923, the House of Representatives demanded to know how much liquor the embassies were importing and tasked Treasury Secretary Andrew Mellon, who oversaw the Prohibition Bureau, to report back. He refused to disclose the information, saying that the diplomats had immunity. Providing this information would be "incompatible with the public interest." Mellon stonewalled throughout the Prohibition era, having no real interest in enforcing a law he didn't believe in. Like Larz Anderson, Mellon was rich enough to casually disregard prohibition.

COCKTAIL INTERLUDE

Something has gone out of life with the passing of famous old Washington institutions as Mullany's, the historic bar of the original Willard's, Shoomaker's, Hancock's and the old Whitney House, of an earlier day. Here were absolutely open forums for the discussion of the principal problems of the day by men who spoke freely under the inspiration of more or less strong drink, which had a tendency to promote eloquence and burst asunder the shackles of convention, conservatism, and caution. The poet has said that truth lies at the bottom of a well, but in reality it lies at the bottom of a wine bottle. Cold water frequently prompts a man to be prudent for selfish interest and an ulterior motive, but he throws discretion to the winds whom Champagne has made honest in spite of himself.
—*George Rothwell Brown,* Washington: A Not Too Serious History, *1930*

Washington's drinking habits changed during the Prohibition era, as bootleggers supplied the market with illicit hooch. Beer all but disappeared. The restaurant culture of enjoying a bottle of wine with dinner was gone. One former bartender, Joe Crowley, lamented in 1928, "Men drank in moderation in those days—little of the guzzling that goes on today, with its resultant drunkenness."

Most Prohibition-era cocktails were made with rye whiskey or bathtub gin (bathtub gin was simply industrial alcohol with juniper flavoring added and then topped off with water from the bathtub spigot. Yummy, huh?). The liquor's taste was often so foul that bartenders adapted by using stronger-tasting ingredients.

Before prohibition changed everyone's drinking habits, Washington had a storied cocktail culture to rival most any city. Following are cocktails from Washington's history.

Joe Rickey

Like air conditioning in a glass on a hot, sultry day. The Rickey was invented at Shoomaker's in Washington in the 1880s and named for lobbyist Colonel Joe Rickey, who was also the bar's owner. It's hard to find an easier cocktail to make.

1.5 oz. rye whiskey or bourbon
juice of 1/2 lime
Apollinaris Mineral Water or club soda

Fill a highball glass with three or four ice cubes. Add whiskey/bourbon, squeeze in lime juice and drop the shell in and then top with club soda.

Variations:
For a Gin Rickey, substitute gin for the whiskey.
For a Sheeney Rickey, simply omit the lime shell.

Mamie Taylor

Historian George Rothwell Brown claimed that the Mamie Taylor was invented in Washington, but other cities lay claim to it as well. It supposedly was invented at Dennis Mullany's on Rum Row in 1903.

2 oz. blended Scotch
juice of ½ lime
ginger beer

Fill a highball glass with three or four ice cubes. Add gin, squeeze in lime juice and top with ginger beer. Garnish with a lime wheel.

Daiquiri

The daiquiri wasn't invented in the United States—it's of Cuban origin—but it was first introduced into the nation at the Army and Navy Club in 1909 by Admiral Lucius Johnson. Caribbean rum became popular during World War II when other spirits were in short supply.

0.50 oz. white rum
0.75 oz. freshly lime juice
1.00 oz. simple syrup

Combine the ingredients in a cocktail shaker over ice. Shake and strain into a chilled cocktail glass. Garnish with a lime slice.

Flower Pot Punch

This was a celebrated cocktail created at Hancock's restaurant, according to cocktail historian Charles Wheeler, who noted that the African American bartenders there practiced a "lost art" before prohibition. He wrote, "In a glass filled with crushed ice were introduced sugar and the juices of lemon and lime, colored red with Grenadine, drenched to the top with Santa Cruz rum and decorated artistically with whatever fruits were in season."

Thanks go to bartenders Phoebe Esmon and Christian Gaal, who re-created the recipe. Phoebe noted, "A revival of that elaborate seasonal garniture, when served in a rocks glass, may have given rise to the name of the drink itself."

2.0 oz. Cruzan three-year white rum
0.5 oz. lemon juice
0.5 oz. lime juice
0.5 oz. pineapple syrup
1 dash grenadine

Fill a rocks glass with crushed ice. Add all of the ingredients and then stir until frosty. Garnish with seasonal fruits and a couple sprigs of mint.

Major Bailey

Renowned bartender Henry William Thomas noted in the 1920s, "This drink was very popular at certain Washington Clubs" for its simplicity, its thirst quenchability and its rather large size. He added, "One quart bottle of gin would make about three of the Baileys." A Lieutenant Bailey was the same, only a smaller, more reasonable size.

4.0 oz. sweet lemonade
1.5 oz. gin (the classic recipe calls for Gordon's)

Fill a highball glass with shaved or crushed ice, then add the lemonade and gin. Serve with a straw.

Virginian Whiskey Punch

A cocktail long prepared by bartender Morrill Chamberlin, when "traditional hospitality yet reigned in Wyoming avenue," wrote historian Charles Wheeler, probably in reference to pre-prohibition cocktail parties in the Kalorama embassy district.

2.0 tsp. sugar
juice of ½ lemon
1.5 oz. rye whiskey or bourbon
sugar

Fill a highball glass one-third full of crushed ice, add sugar and stir hard. Add lemon juice, more ice and whiskey. Stir and stir, gradually adding more crushed ice until the glass is filled to the top and the outside is frosty. Lightly dust the top with sugar.

Cold Apple Toddy

A specialty of George Driver's Bar and comes to us from Charles Wheeler's *Life and Letters of Henry William Thomas, Mixologist.*

For the apples:
12 apples
whole cloves
4 tablespoons butter, cut into small pieces

Preheat the oven to 350 degrees. Peel and core the apples from the top, stopping half an inch from the bottom. Butter a baking dish and then put the apples in the pan. Insert cloves into the top of each slice. Dot the butter on top of the apples. Bake in the oven for fifteen to twenty minutes until half-baked. Remove nine of the apples and let cool; return the other three to the oven and bake another fifteen to twenty minutes until tender and mushy.

For the punch:
1 lb. powdered sugar
2 oz. whole cloves
2 oz. allspice
3 sticks cinnamon
½ gallon apple brandy or applejack
½ gallon water
nutmeg

Combine all of the ingredients except the nutmeg in a punch bowl and stir. Refrigerate for twenty-four hours. When ready to serve, mash the three fully baked apples and stir into the punch. Add the nine half-baked apples so they float on top. Ladle the punch into glasses and grate the nutmeg on top.

HONG KONG (À LA HENRY THOMAS)

The Hong Kong was already an established cocktail, but Henry Thomas, a well-known Washington bartender of the early twentieth century, gave it his spin.

1.50 oz. Scotch whisky
0.75 oz. French vermouth (dry)
0.75 Italian vermouth (sweet)
dash of Maraschino liquor

Mix all the ingredients in a cocktail shaker over ice. Stir and strain into a chilled cocktail glass.

THE FOOLISH COCKTAIL

In 1927, journalist Raymond Clapper noted that the Riggs House on Newspaper Row "was a popular first aid station" for government clerks. It specialized in this cocktail, which he described as "a Martini with a floating slice of onion." It is, in essence, a Gibson.

1.5 oz. gin
0.5 oz. dry vermouth

dash orange bitters
½ of a thin slice of onion

Add the gin, vermouth and bitters to a cocktail shaker over ice. Stir (don't shake) and then strain into a chilled cocktail glass. Float the onion slice on top.

THE COFFIN VARNISH

Though not a Washington cocktail, this is definitely a Prohibition-era invention. Literary critic H.L. Mencken wrote in his memoirs, *My Life as Author and Editor*: "Some time before the Thirteen Awful Years began, we had acquired in Del Pezzo's restaurant, then in 33rd Street opposite the Pennsylvania Station [in New York], the formula of a cocktail that we called the Coffin Varnish—one-third vermouth, two-thirds gin, and a dash of the Italian bitters, Fernet Branca—and this we served to our guests."

1.5 oz. gin
0.5 oz. dry vermouth
dash of Fernet Branca

Mix all the ingredients in a cocktail shaker over ice. Stir and strain into a chilled cocktail glass.

SCOFFLAW

Some American bartenders moved to Europe during the Prohibition era. A week after a national contest to invent a word describing a lawless drinker yielded "scofflaw" in 1924, Harry's Bar in Paris honored the winners with the Scofflaw cocktail.

1.50 oz. rye whiskey
1.00 oz. dry vermouth
0.75 oz. fresh lemon juice
0.75 oz. grenadine

Combine all of the ingredients in a cocktail shaker over ice. Shake and strain into a cocktail glass. Garnish with a lemon twist.

DEMOCRACY ON TRIAL

Politics.
In that one word I can best and most completely describe the greatest handicap to the enforcement of the prohibition law. Politics and liquor are apparently as inseparable a combination as beer and pretzels.

—Mabel Walker Willebrandt, assistant attorney general,
The Inside of Prohibition, *1929*

The dry cause knew that the stakes were high for Washington. In cities like Chicago and New York, they learned that prohibition could be fought, at best, to a stalemate. But Washington was to be the model dry city for the nation. If the capital couldn't be made dry, then how could the country? Contrary to the evidence, drys insisted that "Washington is dry and it's getting drier all the time." They downplayed the arrests and endemic lawbreaking.

The Prohibition Bureau was charged with enforcing the Volstead Act nationally. It was originally part of the Department of the Treasury. President Harding appointed as treasury secretary wealthy banker Andrew Mellon, a man who despised prohibition. He had no intention of obeying or enforcing dry law, even though the Prohibition Bureau was his responsibility. During his eleven years heading the treasury, Mellon lived at the Beaux Arts McCormick Apartments (1776 Massachusetts Avenue), where he rented the entire top floor until his death in 1937. The building is today the headquarters for the National Trust for Historic Preservation.

When the Prohibition era began, Wayne Wheeler of the Anti-Saloon League stacked the Prohibition Bureau with political appointees rather than making them civil servants. That way he could control them. But with their

Treasury Secretary Andrew Mellon was responsible for enforcing prohibition, but he despised the law and stonewalled its enforcement. *Prints and Photographs Division, Library of Congress.*

low salaries and overwhelming odds against them, the bureau proved rife with corruption and was easily bought off by bootleggers. Historian Edward Behr chronicled that, out of the 17,816 Prohibition Bureau agents employed from 1920 to 1930, 11,926 were forced out on suspicion of corruption and 1,587 were dismissed for cause (proven corruption).

In 1927, against Wheeler's objections, Prohibition Bureau agents were made civil servants rather than being political appointees. They were now held to a higher standard. Agents no longer had to find a political patron to find a job; they could apply for one and demonstrate their merits.

Mabel Walker Willebrandt was the rare political appointee who took prohibition enforcement seriously. President Harding appointed her to be assistant attorney general in the Justice Department in August 1921. There she served eight years before resigning in 1929. That same year she published a polemic in support of prohibition called *The Inside of Prohibition.*

She was a strong advocate for prohibition enforcement, perhaps the federal government's most powerful voice. Her argument was, essentially, that we're stuck with prohibition, so we have to enforce it. She didn't question why a huge swath of society was breaking the law—she simply had a job to do. Willebrandt wrote, "The Eighteenth Amendment is doing one thing which is of sobering importance. It is putting democracy on trial." She understood how well the corruption and lack of enforcement of prohibition was undermining the rule of law in the United States.

Willebrandt railed against diverted industrial alcohol—which was renatured into a potable product better known as "bathtub gin"—border smuggling, breweries that were leaking real beer rather than near beer, homemade stills, the politicians who obfuscated actual enforcement, the incompetence of the Prohibition Bureau, political patronage, endemic corruption and violence and ineffective or nonexistent state enforcement. She only offered praise for the incorruptible Coast Guard but discounted that it could only capture a small fraction of rumrunners.

After fighting the good fight for eight years, Willebrandt somehow still believed that the battle could be won if only people got serious about enforcement. She wrote with characteristic bravado, "You can neither coax, scold nor nag people into law observance," though that was ultimately the point of her book, which scolded the federal government, the states and individuals for not taking prohibition serious enough. "Consequently, *enforcement* is the necessary approach at this time," she concluded.

H.L. Mencken countered: "Every newspaper man in America knows that Prohibition is not being enforced—and yet it is rarely that an American newspaper comes out in these days without a gaudy story on its first page, rehearsing all the old lies under new and blacker headlines."

When Warren Harding died in 1923, Vice President Calvin Coolidge was sworn in as president. He was untainted by the corruption that had stained Harding's administration. He was then elected to a full four-year term in 1924. A quiet puritan of a man, Coolidge attended the First Congregational Church, the location of the lengthy service on the evening before prohibition began.

H.L. Mencken wrote cynically about the democratic system that could elect a man such as Coolidge:

> *Democracy is the system of government under which the people, having 35,717,342 native-born adult whites to choose from, including thousands who are handsome and many who are wise, pick out a Coolidge to be head*

Mabel Willebrandt was the assistant attorney general during the 1920s and one of the few political appointees who took prohibition enforcement seriously. *Prints and Photographs Division, Library of Congress.*

of the State. It is as if a hungry man, set before a banquet prepared by master cooks and covering a table an acre in area, should turn his back upon the feast and stay his stomach by catching and eating flies.

Calvin Coolidge was famously reticent. As the former governor of Massachusetts, he gained fame after breaking the Boston police strike of 1919, which earned him a place as Harding's vice president. Coolidge believed in small government and laissez-faire economics. He cut taxes and cut government spending while reducing the federal deficit. During his term in office, the American economy bounded forward, creating what many called "Coolidge prosperity." In hindsight, this was an asset bubble that finally burst in October 1929. But by that point, it was Herbert Hoover's problem, not Coolidge's.

As the governor of Massachusetts, Coolidge vetoed a law allowing 2.75 percent beer, as he thought that the law was unconstitutional given the strict interpretation of the Volstead Act. As president, Coolidge did little to enforce prohibition—enforcement would cost money, and he was too tightfisted to spend. In his memoirs, he mentioned virtually nothing about prohibition, as

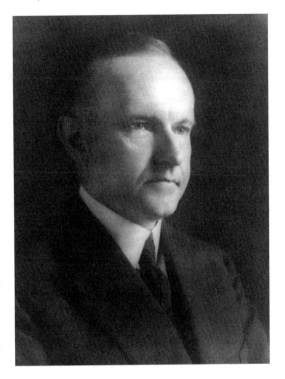

Probably the most frugal American president, Calvin Coolidge did little to enforce prohibition and witnessed an economic boom known as "Coolidge prosperity." *Prints and Photographs Division, Library of Congress.*

if it somehow didn't concern him; perhaps he knew it to be so controversial that saying anything would assuage no one and inflame many.

The Anti-Saloon League held a national convention in Washington on the fourth anniversary of prohibition in January 1924. This was the ASL's thirty-year jubilee convention, but there was little cause for celebration. Already there were visible cracks in public support for prohibition, and more widespread lawbreaking nationwide. New York had sensationally repealed its enforcement act the year before, propelling Governor Al Smith into being the de facto national leader of the wets.

The ASL delegates met with President Coolidge at the White House on January 16; he committed his all in enforcing prohibition (well, as much as he was willing). That night, Governor Gifford Pinchot of Pennsylvania, a dry supporter, delivered a sobering speech on the failure of enforcement, contradicting the other drys who insisted that the bootlegger and speakeasy were things of the past. "The greatest breeder of crimes and criminals in America is the failure to enforce the eighteenth amendment," he accused, calling for a Congressional investigation into Prohibition Bureau corruption. This was a direct criticism of Prohibition Bureau commissioner Roy Haynes,

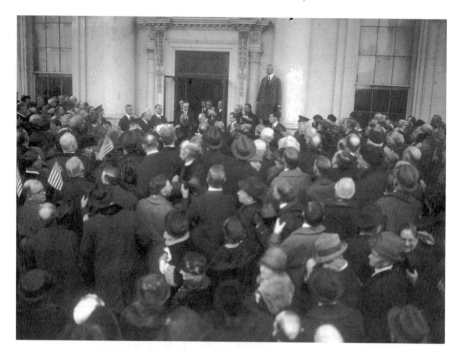

Anti-Saloon League representatives crowd around President Coolidge at the White House during a meeting on January 16, 1924, marking the fourth year of prohibition. *Prints and Photographs Division, Library of Congress.*

who insisted that prohibition was working. Pinchot's speech split the ASL delegates, while Wayne Wheeler worked to smooth things over by insisting that there would be no Congressional inquiry. (Interestingly, this was the same week that the term "scofflaw" was announced. And President Wilson died two weeks later.)

In typical understatement, Coolidge acknowledged the overwhelming weight of the Oval Office. "It costs a great deal to be President," he wrote. He lost both his father and one of his sons while in office. He declined to run for a third term and in 1928 passed the baton to Herbert Hoover.

A GUY LIKE HERBERT HOOVER

Herbert Hoover was a national hero after World War I. As a civilian, he had served five years in Europe, heading the Commission for Relief in Belgium and, later, the American Relief Administration. This brought food to the

starving populations of war-stricken nations and kept millions from dying. In 1921, President Harding appointed him as the secretary of commerce, a position he held until 1928 during the era of "Coolidge prosperity." Without ever having held elected office before, Hoover ran for the presidency in 1928 as Coolidge's Republican successor.

Hoover's Democratic opponent was New York governor Al Smith. In 1923, Smith had signed legislation repealing the state's prohibition statue, leaving enforcement to the federal government. That was one problem, as it alienated Smith from dry voters. The other major problem was that Smith was Catholic. The temperance movement played the Catholic card from the bottom of the deck, claiming that because Smith was Catholic, the Pope would be giving the president orders. Southern Democrats, who were largely white Protestants, abandoned their candidate and voted for Hoover instead. Hoover subsequently trounced Smith at the polls, taking all but eight states.

Hoover mentioned nothing in his memoirs about the Anti-Saloon League, Wayne Wheeler or Bishop James Cannon, the Methodist bishop who had engineered the South's vote for him. Hoover glossed over the 1928 election, claiming that Smith's Catholicism had little impact on the election. "In fact, the religious issue had no weight in the final result," he wrote rather disingenuously in 1952.

Commentator H.L. Mencken thought otherwise, as do many historians, seeing the prohibition issue as tightly bound to religion. The day before the 1928 election, Mencken wrote, "If Al [Smith] wins tomorrow, it will be because the American people have decided at last to vote as they drink, and because a majority of them believe that the Methodist bishops are worse than the Pope. If he loses, it will be because those who fear the Pope outnumber those who are tired of the Anti-Saloon League." Fear of the Pope indeed drove huge numbers of people to vote for Hoover—though the Anti-Saloon League had long overstayed its welcome.

Hoover was a progressive and a technocrat, a successful mining engineer who had a knack for mastering bureaucracy. He was, in many ways, the opposite of Calvin Coolidge's conservatism. While he is largely remembered for his failure to pull the country out of the Great Depression, he initiated many progressive programs designed to spur the economy's growth, such as the Hoover Dam and the Bay Bridge constructions, ending child labor and eliminating the seven-day, eighty-hour workweek. Many of the New Deal building projects in Washington, including the clearing out of Hooker's Division for the Federal Triangle, were started under Hoover's presidency.

Hoover was tasked with defending prohibition, and he took a hard line. He shifted the Prohibition Bureau from the Treasury Department to the Department of Justice, which took enforcement more seriously; he also got it out from under Andrew Mellon. Congress debated modifying the Volstead Act to allow for light wines and beer. Instead, the drys opted for even more enforcement. Congress passed the Jones Amendment to the Volstead Act, which became known as the "five-and-ten" law. That is, people convicted of violating the Volstead Act—even for carrying as little as a quart of whiskey—would be imprisoned for five years or fined $10,000.

Hoover was famous for calling prohibition the "noble experiment." In fact, his actual words at the Republican National Convention in 1928 were: "Our country has deliberately undertaken a great social and economic experiment, noble in motive and far-reaching in purpose." Hoover later wrote of his disappointment with how his words were misconstrued:

> *This phrase, a great "social experiment, noble in motive," was distorted into a "noble experiment" which, of course, was not at all what I said or intended to say. It was an unfortunate phrase because it could be turned into derision. Moreover, to regard the prohibition law as an "experiment" did not please the extreme drys, and to say it was "noble in motive" did not please the extreme wets.*

In his 1952 memoirs, Hoover painted himself as a dry. He declared, "I should have been glad to have humanity forget all about strong alcoholic drinks. They are moral, physical, and economic curses to the race." Yet Hoover was also a closet social drinker. In his earlier job as secretary of commerce, he was fond of stopping by the Embassy of Belgium for a drink after work. The embassies could legally import alcoholic beverages. After the Prohibition era ended, he was fond of a daily martini.

H.L. Mencken wrote cynically about how politicians frame their views to appeal to constituents but disguise their true selves: "Today [the voter] chooses his rulers as he buys bootleg whiskey, never knowing precisely what he is getting, only certain that it is not what it pretends to be. The Scotch may turn out to be wood alcohol or may turn out to be gasoline; in either case it is not Scotch."

The American public was disenchanted with prohibition. They realized that the noble experiment was failing. The prisons were overcrowded, gang violence was escalating—such as the Valentine's Day Massacre in 1929 that made national headlines—and many people feared the breakdown in law

and order. Wayne Wheeler had died in 1927, and the temperance movement lost its main advocate and spokesperson.

As Herbert Hoover entered the Oval Office in 1929, he swore to enforce the Eighteenth Amendment like no other president had before. He asserted that he would "make Washington the model of the country." The Washington Metropolitan Police Department began a new campaign that winter to make the district the nation's driest city.

One speakeasy raid caused political consternation across the board. The location, the fourth floor of 1510 H Street, Northwest, was within a stone's throw of the White House and was raided on November 19, 1929. It was quite the locale, with a fifty-foot mahogany bar that catered to the "best people." But that wasn't the biggest prize. Sergeant Letterman's squad found there a list of prominent clients that included members of the cabinet, a congressman, high-ranking officers and bankers. The *Washington Post* published the list; of the city's four main newspapers, the *Post* had shifted over to the wet column. Henceforth the paper would do all it could to embarrass the dry cause.

In June 1930, the federal government began one of the most intensive campaigns to clean up Washington. Fifteen Prohibition Bureau agents and seventy-five policemen were tasked with shutting the speakeasies. Simultaneous raids across the city arrested dozens of people and seized hundreds of gallons of beer and spirits.

Despite all of the bluster about enforcing prohibition, Hoover knew that the nation was losing its will to fight the battle. He organized the Wickersham Commission to investigate prohibition and to make recommendations. The results weren't helpful. Published in January 1931, the Wickersham Report opposed repealing prohibition but then argued just how futile enforcing dry law was. Both wets and drys claimed that the report supported their viewpoint, bringing the country no closer to a solution. Hoover wrote in disappointment, "Its investigations failed to prove of any great use so far as prohibition was concerned."

Hoover knew that the noble experiment wasn't working, but he couldn't afford to alienate the dry base that had elected him. H.L. Mencken wrote about Hoover's predicament in the *Baltimore Evening Sun*: "But there is no sign that turning wet would help Dr. Hoover in the slightest; on the contrary, it would only split his party and insure his defeat. So there is every reason for believing that, no matter what the Wickersham committee reports, he will keep on good terms with the Methodist bishops and the Anti-Saloon League."

Amos Woodcock, Hoover's director of prohibition enforcement, cracked down hard on the speakeasies, but all this did was alienate more people. He complained that the federal government was doing all of the work, while local and state governments did little. Still, he added five hundred agents to the Prohibition Bureau in 1931, and arrests skyrocketed. With the stakes so high thanks to the Jones "five-and-ten" law, many defendants demanded jury trials, and the court system was swamped with far more cases than it could ever handle.

President Hoover continued with heavier prohibition enforcement, increasingly against public opinion. As the Great Depression set in, brave voices began calling for an end to the noble experiment.

THE MAN IN THE GREEN HAT

C ongress was the source of all national dry laws. It had approved the Eighteenth Amendment and legislated that the District of Columbia become dry. It had passed the Volstead Act enforcing prohibition. It had banned selling alcohol within the U.S. Capitol in 1903 when it closed the Congressional bar. But Congress was never dry, even if it voted that way. The U.S. Capitol sat on a hill of hypocrisy.

In October 1930, less than two weeks before the Congressional midterm elections and a year after the stock market crash that started the Great Depression, the *Washington Post* ran a series of five front-page articles that deeply embarrassed Congress. They were written by George Cassiday, a bootlegger for Congress for ten years. While Cassiday refused to name names, he told how he had supplied most congressmen with booze. The series exposed Congress's insincerity toward enforcing prohibition and sent shudders through the dry community, which realized how deeply they had been betrayed.

In introducing the series, the *Post* editorialized that they would present "a story that will interest every American, whether living in Washington, California, Texas, Maine or Wisconsin." The newspaper recognized that this was a story of national interest—especially less than two weeks before the 1930 midterm election. Members of Congress would be held accountable for their actions during prohibition.

Cassiday began the series with a bold confession: "For nearly ten years I have been supplying liquor at the order of United States senators and representatives at their offices at Washington. On Capitol Hill I am known as 'The Man in the Green Hat.'" He continued: "It may be a surprise and a shock to many good people to know that liquor has been ordered, delivered,

George Cassiday, "the Man in the Green Hat," was a bootlegger to Congress during prohibition. This portrait was taken October 25, 1930, during his series of articles in the *Washington Post. Prints and Photographs Division, Library of Congress.*

and consumed right under the shadow of the Capitol dome ever since prohibition went into effect."

Cassiday met most of the members of Congress during his ten years bootlegging. He acknowledged that other bootleggers existed—he couldn't possibly supply every congressman's needs—but he believed he had the greatest market share of any liquor supplier. He observed: "As the result of my experience on Capitol Hill since prohibition went into effect I would say that four out of five senators and congressmen consume liquor either at their offices or their homes." *Four out of five* members of Congress! These were the same people who had legislated prohibition and funded the budget for its enforcement.

Congressional drinking was a not-so-well-kept secret. *Washington Post* columnist George Rothwell Brown joked in 1927, "Senator [William] Bruce says that all the Senators who have declined to take a drink since he has been in Washington could be put in a taxicab...The real question is, are there taxicabs enough to hold the Senators who do?"

How Dry We Weren't

Eighty years after Cassiday's revelation, on a balmy October evening in 2010, Fred Cassiday, his wife, Karen, and son, Danny, met me for beers and pizza at Liberty Tavern in Arlington. Born in 1948, Fred is George Cassiday's youngest son (he has an older brother) from his father's second marriage. Fred retired from the U.S. Air Force Reserve as a senior master sergeant. Karen donated a kidney to her boss in a socially responsible public relations firm, and both of their grown children served in the Peace Corps. I joked that this family of do-gooders is making up for the bootlegging sins of their father.

Fred explained how his dad came to be. It's remarkable and unusual, one of those only-in-America stories. George was born in 1892 in Wheeling, West Virginia, in a Methodist family, and his mother was a member of the WCTU. This made for a dry house. He advanced only through the third grade, and that was the end of his formal education; his parents sent him to work in a glass factory. There he lost part of his index finger in an accident.

Cassiday was proud of his country and his Irish ancestry. He was an idealist, one who volunteered to fight on the British side early during World War I and then with the Canadian army before the United States even entered the war in 1917. He finally served as a tanker in the American Expeditionary Forces. Fred explained, "He was like, 'My country, right or wrong.'" After World War I, he returned to the states and founded the Irish War Veterans Association. The future bootlegger noted that on the troop ship returning from Europe, the 2,200 American soldiers took a straw poll on the question of prohibition. Only 98 were in favor of it.

George Cassiday got into the bootlegging business by accident. He couldn't qualify for his earlier job working for the Pennsylvania Railroad, and he was looking for employment. "A friend of mine told me that liquor was bringing better prices on Capitol Hill than anywhere else in Washington and that a living could be made supplying the demand," he wrote in the *Post*. With a young family to support, he jumped at the opportunity. That friend introduced him to two southern congressmen—both of whom had voted for the Eighteenth Amendment and the Volstead Act—and he agreed to procure for them a supply of liquor.

These two congressmen then introduced him to other members, and word spread. "It was not long before I had the run of the Senate and House Office Buildings and was spending more time there than most of the representatives," Cassiday explained. He would only do business with people he had been introduced to and learned he could trust. Cassiday didn't attempt to get into other lines of business or sell outside of Congress. He limited himself to his Congressional constituency. This probably kept

him out of trouble longer than most other bootleggers, though trouble was always right around the corner and indeed inevitable.

So how did someone with a third-grade education—a man who could swear like sailor and whose biggest life experiences were working in a glass factory and fighting in the Great War—succeed at becoming a bootlegger for Congress? In short, Cassiday had remarkable people skills. "Someone who has gone through all that, he didn't seem intimidated by anyone," Fred explained. "My dad was a real gregarious kind of guy. It didn't matter if you were a janitor or a president of a company—he could have a conversation with you." These interpersonal skills served him well as he developed relationships and trust with congressmen and their staffs.

Fred has original copies of the *Washington Post* articles. Some of them even have comments that his dad made in the margins. He noted that his dad had beautiful handwriting, unusual for someone with so little education. Then again, so did Abraham Lincoln.

Like many congressmen who came to Washington as outsiders, Cassiday soon learned that personal connections were the key to success: "I found out in ten years in the House and Senate Office Buildings that my business could not be conducted along political lines. It is true that I served more Republicans than Democrats and more drys than wets, but that was only because the Republicans and the drys have been in an overwhelming majority in both branches of Congress during that period."

Cassiday observed about congressmen: "Some of them I found were mighty good fellows, and others not so good, but I learned right off the bat that when it comes to eating, drinking and having a good time in general, they are as human as other folks." Much of the nation was disregarding prohibition, and perhaps congressmen felt that they could casually disregard the law as well.

"It is hardly necessary for even the most impassioned dry congressman to pull down the blinds in Washington when he wants to wet his whistle," wrote Raymond Clapper for *American Mercury* in 1927. "The Prohibition agents there all have very poor eyes."

Since Cassiday's first customers were southerners, moonshine was the most popular initial product, but as he expanded his base he soon shifted to whiskey. He found a steady supply to meet his constituents' needs. He had a good contact, a former Department of Justice employee, who put him in touch with wholesalers operating near Pennsylvania Station in New York City. Cassiday frequently took the train to New York, filled his suitcases ("One man could carry 30 to 40 quarts in two large suit cases") and then ride the rails back home. As the decade progressed, he shortened the supply line

to Newark and Baltimore and then Philadelphia. Philadelphia was home to one of the nation's largest bootlegging operations, fronted by the Franklin Mortgage and Investment Company. Fred didn't know from whom his dad bought the booze, but friends and his first wife sometimes went with him to help carry liquor back. "I didn't see him drink whiskey very often, but he loved his beer," Fred remarked. "Yuengling was his favorite."

One time, while walking through New York's Penn Station with a suitcase loaded with liquor, Cassiday set the suitcase down too hard, and several bottles broke inside. A passerby said to him knowingly, "Say, Buddy, your clothes are leaking."

Cassiday was never part of a gang or criminal enterprise; he was a one-man operation. He had no bodyguard and apparently carried no gun. In this sense, Washington was quite different from other cities. He was never under threat from competing organized crime organizations, nor did he have to bribe his way to the top or to stay in business. Most bootleggers in Washington were amateurs, and there were plenty of them.

"I think he had congressmen and senators who protected him—and he kept them supplied," Fred explained. Perhaps he should have taken more precautions; the police occasionally raided Cassiday's Capitol Hill house at 303 Seventeenth Street, Southeast, and confiscated his wares. Streetcars crisscrossed Washington at the time, so it was easy to get to the U.S. Capitol or to Union Station to restock.

Why didn't Washington become infected with organized crime like other cities? Fred Cassiday may have the answer:

> The bad guys knew that if they tried to set up shop in the nation's capital, there would be a world of pressure and pay out. The multi-jurisdiction and overlapping authorities would make for a very expensive protection expense. Not to mention that D.C. had tons and tons of civic-minded people that had moved here to support the government during the war. A lot of damage would be done to them constantly by just a few people of such a mindset. D.C. was primarily a government town.

Getting the booze daily into the (now Cannon) House Office Building was a challenge until a congressman friend came up with a brilliantly simple solution. He asked Cassiday, "George, did it ever occur to you it would be easier to bring supplies into the building in larger lots and distribute it from a base of operations from the inside?" Cassiday literally became an inside man. He was given a key and a storeroom that effectively served as his office.

The Cannon House Office Building on Capitol Hill, where bootlegger George Cassiday supplied Congress from 1920 to 1925. He then moved to the Senate side. *Garrett Peck.*

There he stored his products for distribution, moving the goods into the building at night or during times when there was a lot of foot traffic and his entry could go unnoticed. This worked fine until one day when he realized that up to $600 in booze had been stolen directly from his storeroom.

Once inside, Cassiday's operation was remarkably low-risk. Everyone else had to open their bags for U.S. Capitol Police to inspect when they left the building, but not congressmen. Congressmen could use their privilege to take liquor out of the building once they took stock. When supplies ran low, Cassiday admitted to cutting his liquor with water, grain alcohol and flavorings.

Cassiday had an active social life in the House Office Building. He had an informal group of friends called the Bar Flies Association that met in his office for drinks. He also played poker with congressmen in the basement. He wrote, "From 1920 to 1925 were the good old days for me, and I like to look back on them. The House Office Building got so it seemed like home to me." On a normal day, Cassiday filled twenty to twenty-five orders.

Cassiday had little trouble for the first five years of his operation. He was arrested once in a sting, and the police raided his home in 1922 and 1925, confiscating liquor worth $4,500. But then came the incident in which he earned his nickname, the Man in the Green Hat. In 1925, Cassiday was arrested by a U.S. Capitol policeman while carrying a briefcase with liquor into the House Office Building. (The policeman filled out the warrant for his

arrest after the fact; the man had conveniently looked the other way for years, so someone probably tipped him off.) Cassiday was wearing a green felt hat, and the press took note. He pleaded guilty to this charge and to the earlier sting, both misdemeanors. The judge sentenced him to ninety days in jail.

Cassiday's son Fred told the *Washington Post* in 2009, "He never went anywhere without a hat. We used to make fun of him. It was old. It obviously had been well worn, but if you looked at that hat today, you'd say, 'My god, this guy really has a classy hat.'" But Fred also told me that he never saw the actual green hat—the legendary top piece disappeared from his wardrobe.

After his arrest, Cassiday was banned from the House Office Building. The poor representatives didn't suffer, as six other bootleggers kept them well supplied. Journalist Walter Liggett wrote in 1929, "The busiest House bootlegger is on the government payroll."

Cassiday shifted to the Senate Office Building. He found senators to be more discrete, seldom willing to meet with him openly. "I found the senators more cautious and a shrewder class of people, generally speaking," than representatives. As a result, not one senator was ever arrested, while several congressmen were taken into custody for Volstead Act violations. Cassiday explained, "For instance, most of the senators would order their liquor through their secretaries. In delivering the order you would not see the senator at all in some cases. But when a young girl or a committee clerk receiving a salary of $150 or $200 a month ordered a case of stuff that sold at a price of from $100 to $160 a case, you could be pretty sure you were dealing with a go-between." One senator stored his booze in his library behind the Congressional Record. When he needed a resupply, he would ask Cassiday for "new reading matter." The senator called Cassiday his "librarian."

Cassiday noted how his own customers—congressmen and senators—would speechify about the merits of prohibition. "I have sat in the gallery and heard one of my customers deliver a rattling good prohibition speech. On other occasions I have heard members of the House and Senate make strong arguments on the floor that prohibition was being well enforced when I knew good stuff was being regularly delivered at their own offices for use by their secretaries or clerks." This further exposed the two-faced system of dry Congress, wet congressmen—they were dry in name only.

Prohibition Bureau commissioner James Doran finally infiltrated an agent, a nineteen-year-old youth, to catch Cassiday. Cassiday responded to a fake liquor order in February 1930 and was arrested. His days as a bootlegger were over.

Cassiday's final article in the *Post* was published exactly a week before election day in 1930. It dealt with the question of Congressional drinking and laid the question directly at the feet of the voters. Cassiday pointed out that, while most of Congress drank, they genuinely feared their constituents' response if they ever learned this fact.

One wet congressman who always voted dry demonstrated this dilemma: "George, I know my district is overwhelmingly dry. The people there believe in prohibition. They can have my vote for all the prohibition legislation they want as long as they want it. If the day comes when I get ready to retire from Congress it will be time enough for me to vote the way I drink."

Cassiday went on to note that "[t]his particular member had no wish to keep liquor away from the other fellow, but he figured it as a practical matter that if he wanted to keep his seat in Congress he would have to vote with the majority of his constituents on this question. I found that same view pretty general among my 'dry' customers." It reflected the power that the Anti-Saloon League could unleash on a poor member of Congress who simply voted his conscience. The ASL had demanded absolute loyalty to the dry cause, or else. But when Wayne Wheeler died in 1927, the ASL quickly lost its grip on power, though few realized it yet.

In her 1929 biography *The Inside of Prohibition*, former assistant attorney general Mabel Walker Willebrandt acknowledged that most of Congress was wet but voted dry. She wrote, "Congress remains overwhelmingly dry in its votes, whatever the personal habits of the members may be. A congressman who comes up for reelection every two years cannot afford to be wrong about the wet or dry sentiment of his district. He *knows*."

Cassiday downplayed how much money he made from bootlegging. He had a family to support, and his overhead was high. "The truth is that I never made more than a good living to support myself and my family," he wrote in the *Post*. Nonetheless, Fred pointed out that he purchased a new car every two years—an expensive luxury in the 1920s.

Cassiday concluded his series of articles by declaring that he was hanging up his green hat. "I want the world to know that I am through working on Capitol Hill, or any place else, in the kind of business that has engaged me for the last ten years." But he directed one final question at everyday readers: "Considering that I took the risk and did the leg work from 1920 to 1930, I am more than willing to let the general public decide how I stack up with the senator or representative who ordered the stuff and consumed it on the premises or transported it to his home." In other words, if I'm guilty, then so is almost every member of Congress.

How Dry We Weren't

Mabel Walker Willebrandt had likewise written about her revulsion with Congress in 1929: "I think that probably nothing has done more to disgust and alienate honest men and women who originally strongly favored the prohibition amendment and its strict enforcement than the hypocrisy of the wet-drinking, dry-voting congressmen."

Having met most members of Congress, Cassiday knew where they stood on the question of ending prohibition. He believed that two-thirds of Congress would vote for repeal if they thought their constituents would support them. Many would never get the chance: In the elections that followed the next week, the Democrats seized control of both the House and the Senate, ousting many dry Republican incumbents and replacing them with wet Democratic freshmen. The ASL's control of Congress had been broken.

Cassiday's articles in the *Washington Post* were certainly a contributor to the Republican defeat, but the wider issue was the Great Depression. The economy was imploding, people were being laid off and their savings had evaporated. The public desperately wanted change. The Republicans in Congress were given the boot.

After his arrest in February 1930, Cassiday was convicted of a felony and sentenced to eighteen months in jail. "My mom and him both told me he actually never spent a night in jail," Fred told the *Washington Post*. "What he would do is, he would go there in the morning every day, sign himself in, and then, at the end of the day, sign himself out." But that was the end of Cassiday's bootlegging career. He went on to work in a shoe factory and several hotels in the Washington area. He died in 1967 at seventy-four. Fred was just eighteen years old then.

Fred said that his mom destroyed the "black book," the book that George Cassiday used to keep track of his customers and their purchases. His dad never revealed who his customers were—beyond admitting that it was most of Congress. What a shame. Though embarrassing to congressmen at the time, the black book was a real part of history and would certainly be a proud part of the Library of Congress or the National Archives today.

George Cassiday was a most unusual bootlegger. Articulate, well connected and outspoken, he never stooped to violence. Most bootleggers never told their story. Yet here he was, flaunting it before a national audience. "Most guys were trying to hide their occupations," Fred told me. "I sense he had some part in helping end Prohibition."

133

The Hummingbird Flew to Mars

In September 1930, Morris Sheppard—the Democratic senator from Texas who had passed the Sheppard Act to dry up the District of Columbia and the author of the Eighteenth Amendment, remarked, "There is as much chance of repealing the Eighteenth Amendment as there is for a hummingbird to fly to the planet Mars with the Washington Monument tied to its tail." That hummingbird was, in fact, getting ready for liftoff.

George Cassiday's sensational story provided necessary ammunition for wets, who now had plenty of evidence that prohibition wasn't working. Backed by a public that had soured on dry law, the wet forces were ascendant. The movement rapidly grew, fueled in part by the Women's Organization for National Prohibition Reform (WONPR), which sought to be a counterweight to the Woman's Christian Temperance Union. WONPR opened a Washington office in 1929 and signed up thousands of members.

The WCTU found itself on the defensive, as evidenced by the minutes of its Washington annual convention, held in October 1931. The members claimed that drinking wasn't on the rise at colleges, that WONPR was unaccountable and didn't have as many members as it claimed and that the only people who wanted prohibition repealed were middle-age and older men. One speaker said, "The greatest weapon we have as Christian women is 'prayer,' God will bring to naught those who are endeavoring to destroy our prohibition law." Among the resolutions was passed one claiming, "We believe the enforcement of prohibition is steadily improving" and another that called on Hollywood to stop showing drinking in movies, claiming it was "unpatriotic."

THE CRUSADERS

WONPR justifiably gets credit for influencing public opinion that prohibition's time had passed. But another organization was particularly important for Washington politics, in part for the dynamic leadership of its local office. This group was the Crusaders.

Organized in 1928, the Crusaders was a wet organization that crusaded to end prohibition. Many of the organizers were too young to vote in 1918 or were fighting the Great War. Its slogan was "We're not wet, we're not dry—join The Crusaders and substitute real temperance for prohibition intemperance."

The Crusaders took on the Anti-Saloon League and its powerful local office in Washington. If prohibition's creation can be credited to Wayne Wheeler, then it's undoing should be credited to Rufus Lusk. A World War I army captain, he headed the Crusaders' Washington branch and served as its national publicity director. He was perfect for the job, knowing just how to capture public attention and generate interest in repeal.

Lusk's grandson, Rufus Lusk III, described his grandfather for me: "He was a very good speaker. Very persuasive. And he was an Irishman, so Prohibition was an affront." Lusk graduated from Georgetown University in 1917, where he won the debating award. He formed a real estate publishing firm, Rufus S. Lusk & Son, as "he loved data. He loved to use it to make a strong point."

Lusk put his love of data to good use. Realizing the power of a picture to tell a story, Lusk and the Crusaders began publishing maps to make their case. These became some of the most effective tools in the wet arsenal. In October 1930, just weeks before George Cassiday went public with his story, the Crusaders mapped 934 speakeasies raided in seven months in Washington, based on Metropolitan Police data. This was a map that first ran in local newspapers but soon appeared around the world. The 1930 speakeasy map of Washington spoke volumes about the high number of gin joints in the city. In presenting the map, Lusk commented:

> *This map shows that a dozen speakeasies literally surround the Prohibition Bureau. It demonstrates that dispensaries of bootleg liquor are not confined to slums and alleys, but cluster thickly in Washington's finest residential section, adjacent to the homes of Cabinet officers, senators, representatives in Congress, Army and Navy officers, Government officials, members of the Diplomatic Corps and the social prominent in the Nation's Capital.*

Before the Prohibition era began in the district in 1917, there were only three hundred licensed saloons. It was clear from the 1930 speakeasy map that there were more than three times that many speakeasies *caught* selling alcohol—and many more operating.

A month later, the Crusaders released the results from a poll of members from three distinguished clubs in Washington: the Metropolitan, the Cosmos and the Army and Navy. This was to counter the WCTU's claim that "every good man and woman wants prohibition." It surveyed 446 members, 80.3 percent of whom wanted the Eighteenth Amendment repealed.

When the Anti-Saloon League held its convention in Washington in January 1932, the Crusaders published a world map showing how many countries had gone from dry to wet since 1920: Canada, Finland, Norway, Sweden and the Soviet Union. Only the United States and Prince Edward Island were still dry. The global movement to dry up the world had failed.

In 1930, Senator Robert Howell proposed a "home raid" bill that would allow police, without a warrant, to raid private residences suspected of distributing alcohol. It met significant opposition, but Howell kept at it for several years without success. He remarked, "Washington is a bootleggers' sanctuary." Former representative William Upshaw of Georgia, a leading

In this clever 1926 photo, Georgia representative William Upshaw seems to keep the U.S. Capitol "dry" with his umbrella. Few congressmen were dry in real life. *Prints and Photographs Division, Library of Congress.*

dry in Washington and the Prohibition Party's presidential candidate in 1932, said smartly, "Liquor will make a Democrat think like a Republican. It will make a Democrat smell like a Republican."

When Senator Howell brought up the home raid bill again in February 1932, the Crusaders took up the charge. Rufus Lusk came to the Senate District Committee armed with an updated Washington speakeasy map. This noted 1,155 locations where police purchased alcohol and then raided in 1931 (there were another 516 raids that failed to find alcohol). That was more than three raids per day. The 1932 map was more professionally produced than the 1930 version, and it ran in newspapers nationwide.

The updated speakeasy map prominently showed the location of the Anti-Saloon League's local office across from the U.S. Capitol—along with six dots indicating raids within a stone's throw. Notably, three large stars indicated government properties where speakeasies were raided, including a War Department office just a few doors down from the ASL. The map

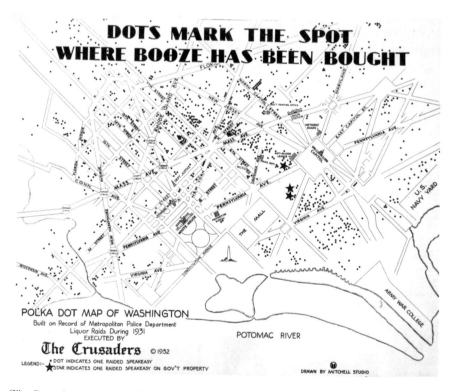

The Crusaders mapped 1,155 speakeasy raids in Washington in 1931 and published it in newspapers nationwide. Washington was far from a model dry city. *Prints and Photographs Division, Library of Congress.*

showed five sites where alcohol was purchased on the same block as the WCTU. Two purchases were made right behind the Prohibition Bureau.

A key wet ally, Senator Millard Tydings of Maryland, hung the map in the Senate chambers for all to see—especially Senators Howell and Sheppard. The intention of the map was to embarrass the dry forces by showing that Washington was anything but a model dry city. The ASL countered that the map provided ample evidence that prohibition *enforcement* was effective—but members couldn't say that prohibition itself was working, else why would so many people be scofflaws?

Lusk wrote damningly in a September 1932 article, "The drinking of hard liquor has increased until the country has lost its taste for good beer and wines. Three speak-easies have sprung up in the place of each licensed saloon. Indeed, drinking is done almost everywhere by almost everybody." Change was just around the corner, prompted by economic disaster.

The Great Depression

Prohibition was passed during World War I as a bipartisan issue. But it became a Republican issue to defend: the GOP controlled the presidency and Congress throughout the 1920s. And subsequently, they were blamed when prohibition failed.

But repealing prohibition seemed an impossible task. How would you ever get thirty-six states to admit that they had made a mistake and change the Constitution back? The answer came when the economy fell off a cliff in October 1929 and the Great Depression began. A seismic shift in the political balance took place in 1930 and 1932 because of the Depression, repudiating Republican policies that hadn't saved the economy. The Democrats took over Congress, and Franklin Delano Roosevelt was elected president.

The Great Depression changed the character of the prohibition debate. The country desperately needed jobs. Organized labor was drumming for beer. The Democrats made political hay of this. With the public rapidly coming around to the view that prohibition should end, President Hoover struggled to bridge a middle course that satisfied no one. The debate over alcohol was as polarizing as ever, but now the wets—and the Democrats—had the upper hand.

H.L. Mencken wrote about the role of prohibition in Herbert Hoover's epic defeat in the 1932 presidential election. As it became clear that he was

going down in the polls, Hoover changed his stance on prohibition, saying that he would consider changing the Volstead Act. That did little to win voters to his side—the Democrats had already promised that and much more. "He was too stupid to see that the vast majority of people were sick of it, and too cowardly to risk the crumbling fangs of the Anti-Saloon League, and in consequence he hung onto the Eighteenth Amendment at least two years too long, and when he turned on it at last he seemed a traitor rather than a hero," noted Mencken in the *Baltimore Evening Sun*.

Larz and Isabel Anderson, the wealthy couple with the Kalorama mansion, were committed Republicans, but even they had their limits when it came to President Hoover, whom they detested. The Hoovers didn't entertain as high society expected. There were no grand parties and certainly no cocktail parties, so the aristocrats felt slighted. "There had been so many reformed drinkers in high official places to dull the pleasure of life (for there is nothing so dull as a reformed drinker) and the hypocracy [*sic*] of their attitude made insincerity the wear," Anderson complained in his journal. They cheered the election of Franklin Delano Roosevelt in 1932, a fellow aristocrat who enjoyed his daily cocktail.

The Democratic Party adopted repeal as part of its platform—not that members were pro-alcohol, but rather because it was a law-and-order issue. Repeal would get the beast back under control and short-circuit the violent lawlessness that had overtaken the cities. And with the Great Depression, the Democrats successfully argued that reopening the breweries and distilleries would create hundreds of thousands of jobs—and generate revenue for the federal government. Repeal would help get the economy moving.

Even the Republicans were divided on the issue. Many of them saw the writing on the wall. Journalist H.L. Mencken attended the Republican National Convention in Chicago in June 1932 and saw the wets route the drys, led by Bishop James Cannon of the ASL. "It was pleasant to see them palpably licked, but it was also somewhat sad," Mencken wrote for the *Baltimore Evening Sun*. "Here were the most accomplished political manipulators ever on display in the America of my time, and now they were brought down at last and their old enemies were gloating over them."

Some were skeptical that prohibition would ever end. Prohibition Bureau agent extraordinaire Izzy Einstein, who had dazzled the public with his comical disguises and bootlegging busts, insisted that the noble experiment was permanent. He penned in his memoirs, published in September 1932, "Prohibition is here to stay. The Amendment will not be repealed, in our

lifetime at least." He reasoned that bootleggers and speakeasies would be put out of business, so these people would never support repeal. He also pointed out that the price of booze had fallen drastically but failed to note its cause: with the Great Depression, so many people were out of work that they simply couldn't afford the luxury of a drink. It didn't take long for Izzy to be proven wrong.

Just two weeks before election day in 1932, Roosevelt had made a huge promise that thundered across the United States: He promised to legalize beer. H.L. Mencken was in the audience at Baltimore's Fifth Regiment Armory when Roosevelt concluded a speech with "the magical word beer." He described the palpable excitement for the *Baltimore Evening Sun*: "The whole house arose to its legs and cheered. This is what the crowd had come for—that and nothing else. Beer in our time. Beer tomorrow. Beer this afternoon. Beer right now...What this country needs is a good 5 cent glass of beer." That last line was a well-recognized pun: Woodrow Wilson's vice president, Thomas Marshall, had famously remarked,

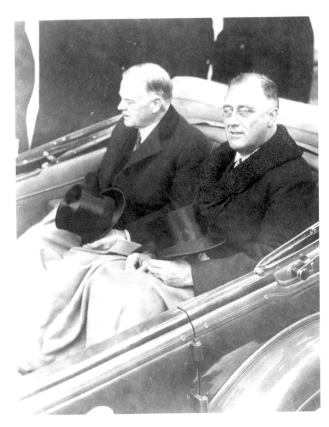

With the Great Depression, Americans handed their political fate to the Democrats. Franklin Delano Roosevelt trounced Herbert Hoover in the 1932 presidential election. Here they ride to the U.S. Capitol on inauguration day in 1933. *Prints and Photographs Division, Library of Congress.*

"What this country needs is a good 5 cent cigar." Mencken added, "There can be no question that [Roosevelt] was believed. He looked very thirsty himself."

Roosevelt won a landslide victory in the 1932 election. He was elected to the presidency with a mandate to end prohibition.

REPEAL

On February 20, 1933, the newly elected wet Congress passed the Twenty-first Amendment and sent it to the states for ratification. Senator Morris Sheppard, the Eighteenth Amendment's author, briefly filibustered the bill. The repeal amendment stated that states would vote by convention—that way the Democrats could control the process. They were solidly in control of the country now.

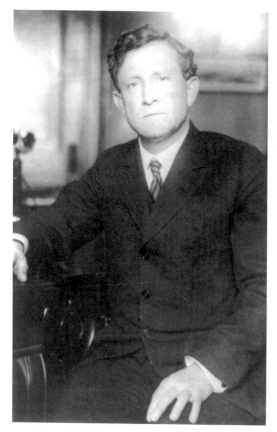

A 1934 photo of Senator Morris Sheppard of Texas. He authored the Eighteenth Amendment and the Sheppard Act and briefly filibustered the Twenty-first Amendment (repeal). *Prints and Photographs Division, Library of Congress.*

How Dry We Weren't

On April 6, 1933, just a month after Roosevelt entered the White House, FDR made good on his promise to legalize beer. He signed into law the Cullen Act, which declared that 3.2 percent beer was nonintoxicating and thus didn't violate the Eighteenth Amendment. (Rufus Lusk of the Crusaders received one of the five pens the president used to sign the bill.) The law went into effect at midnight that night. The Yuengling Brewery from Pottsville, Pennsylvania—the nation's oldest brewery—sent the first case of beer to the White House. Millions of people took to the streets around the country in the wee hours of April 7 and had a five-cent beer at reopened bars. It was the worst part of the Depression, and unemployment stood at 25 percent, but Americans finally had had something to celebrate. Everyone knew that prohibition would soon be over.

Democrats in Congress reduced funding for prohibition enforcement. Seeing the writing on the wall, Prohibition Bureau director Amos Woodcock shifted his bureau's enforcement attention away from speakeasies and targeted wholesalers instead in March 1933. Raids in Washington continued, of course, including the high-profile bust of the Mayflower Club.

Never a prohibition supporter, Larz Anderson grew more ever more excited as the noble experiment wound down. "And then all autumn long the end of prohibition, the approach of Repeal, had excited everyone, rich and poor, wet and dry," he wrote in his journal. "It seemed incredible that in so short a time so momentous a change could have taken place—a year ago it had seemed only a dream."

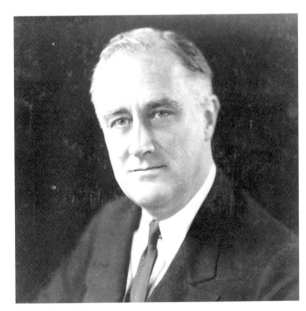

Franklin Delano Roosevelt's election platform in 1932 promised to repeal prohibition to reopen the breweries and distilleries to create jobs and taxes. He delivered on that promise in his first year in office. *Prints and Photographs Division, Library of Congress.*

The first state to pass repeal was Michigan on April 3, 1933, just four days before the Cullen Act celebrations. The remaining state conventions met soon after, so eager was the country to end prohibition. There was finally a national consensus that prohibition had failed. It only took eight months for the Twenty-first Amendment to be ratified. On December 5, 1933, Utah became the thirty-sixth state to ratify the amendment. That may seem surprising, as Utah is dominated by Mormons, and Mormons don't drink alcohol. But there was strong support for repeal, even among nondrinkers, who wanted to reestablish law and order.

There was no big national drunken celebration when Utah ratified the repeal amendment. Larz and Isabel Anderson were at their Massachusetts home in Brookline when prohibition ended. Hearing over the radio that Utah had just voted, Anderson immediately called for his wife. "I.A. joined me at once in a champagne cocktail, for I had looked forward through the years to champagne at such a moment." He continued:

> It was expected that during the evening there would almost be riots of frenzied drinkers taking advantage of the new freedom (new for many who had grown up during cursed prohibition)—and the police were all prepared but, wonderful as it may seem, with thousands of festive throngs milling the streets of Boston and crowding the restaurants till all hours of the morning on this night of nights, there were _fewer arrests for intoxication than a year before in the era of prohibition._

H.L. Mencken issued a statement of relief that the noble experiment was over. "The repeal of the eighteenth amendment means vastly more than the return of the immemorial beverages of civilized man. It means, above all, the restoration of one of the common liberties of the people."

National prohibition was over, but not for the District of Columbia—at least not yet. The Sheppard Act was still in effect. It took a Congressional act to allow alcohol in the district again. The Crusaders yet again stepped up. A week after national repeal, Rufus Lusk presented a plan to regulate alcohol in Washington through a model liquor licensing bill. In place of unfettered bootlegging would be alcohol licensing, regulation, taxation and a control board. Lusk proposed a drinking age at eighteen, except for any alcohol with 14 percent alcohol by volume or higher, in which case you had to be twenty-one. It established licensing for bars, hotels, restaurants and retail establishments to sell alcohol.

Congress quickly debated Lusk's measure—drys countered with a dispensary system, but that was turned down—and then passed the licensing bill in mid-

January 1934. It gave the district commissioners forty-five days to establish an alcohol control board and allow businesses to apply for licenses. Though Washington failed at being a model dry city, it became a model for how states could license and regulate alcohol. Most states adopted similar licensing as they established Alcoholic Beverage Control (ABC) boards. The Sheppard Act came to an end on March 1, 1934. In the intervening three months, district residents had scurried over the border into Maryland to buy newly legal booze.

On February 6, 1934, the elegant Mayflower Hotel (1127 Connecticut Avenue) was the first to apply for a liquor license. It paid $1,000 for a Class C license to dispense beer and liquor. Work began immediately on building the Mayflower Lounge, the hotel's bar (sadly, the bar's legendary successor, Town & Country, was closed in January 2011). The hotel had opened in 1925, but despite its high-end clientele, it did not serve alcohol. Franklin Roosevelt wrote his 1933 inaugural address at the hotel. The Women's Organization for National Prohibition Reform (WONPR), a leading anti-prohibition group, met at the hotel for its April 1933 convention.

Prohibition in Washington, D.C., ended on March 1, 1934. At midnight on February 28, police acting as messengers delivered the first two hundred licenses to bars, clubs, hotels and retail establishments. The National Press Club got the first liquor license in the city—hand-delivered by Commissioner George Allen of the ABC Board, who recognized a photo op when he saw one. Behind the police came delivery trucks, wholesalers who delivered legal beer, spirits and wine to the newly licensed establishments. For the next two hours citizens across the city enjoyed their tipple—that is, until the 2:00 a.m. closing time. But it was no matter. Prohibition was over. The newspapers reported that the evening was quiet and that there was no drunken celebration or public disturbances. People generally behaved.

Retail establishments and restaurants opened the next morning with their liquor licenses in hand. Liquor stores found that the demand for legal liquor was brisk, as people lined up down the street. The *Washington Post* commented, "Somehow or another, despite 17 years without it, Washingtonians seemed to hold their liquor quite well."

Not all Washingtonians were happy about repeal. Howard University dean Kelly Miller commented, "It is a dangerous precedent to rescind a righteous law. The whole fabric of social order is weakened thereby. The rescindment of the eighteenth amendment is the first instance in the direction of moral apostasy." He worried that Americans could repeal any law—including laws that protected African Americans such as the Fourteenth and Fifteenth Amendments, which were being actively ignored in the South.

The return of liquor to Washington passed almost unnoticed in the local black press. On March 1, 1934, the *Washington Tribune* headlined a small protest against a luncheonette in the Masonic Temple at U and Tenth Streets that had applied for a liquor license. This was hardly riveting or front-page news. A week after repeal, on March 10, the local *Afro-American* was suddenly awash in liquor store and restaurant ads, most of them black businesses that had gone legit. The Christian Heurich Brewing Company began advertising in the black newspapers as well.

Many clubs, hotels and retailers that still exist today were among the first two hundred to get liquor licenses. They included the Mayflower Hotel, the Hotel Washington, the Willard Hotel, the Shoreham Hotel, the Army and Navy Club, the Metropolitan Club, the Cosmos Club and the University Club. Ace Beverage, now in Foxhall, was one of the first liquor retailers. For years it was in Adams Morgan. Plain Old Pearson's Wine & Spirits in Glover Park was once Pearson's Pharmacy, which sold medicinal liquor. Its owner, "Doc" Eisenberg, saw his pharmacy business plummet, so decided to compete by opening a liquor store—Plain Old Pearson's.

In its first annual report, the D.C. Alcoholic Beverage Control (ABC) Board reported that it had already issued 1,660 licenses by July 1, 1934, greatly increasing the number of bars and retailers constrained by the Jones-Works Excise Act three decades earlier. The board reported that the number of arrests for intoxication rose after repeal from around 1,500 a month to more than 2,100 a month—especially starting in March 1934, when drinking became legal again. It wasn't the youth who were troublesome—40 percent of the arrests were people aged forty and older. Meanwhile, traffic accidents actually declined, the speakeasies were being driven out of business and, most surprising of all, the city's licensed establishments were on a hiring spree of more than four thousand people. Repeal had contributed more than $1 million in taxes to the city's coffers.

In 1970, fifty years after the Prohibition era first began, journalist Edward Folliard recalled the era that he covered as a cub reporter: "Looking back on it all, the striking thing about prohibition was that so many people could have been so utterly wrong." The temperance movement seriously misjudged how deeply ingrained drinking was to American culture or how paramount drinking was to Washington society. Discredited and unpopular, the temperance movement went virtually extinct, leaving only the ugly Temperance Fountain as a monument.

Appendix
THE TEMPERANCE TOUR

The Temperance Tour is a fun walking tour of prohibition-related sites in Washington, D.C. I started leading the tour in 2006 as a volunteer tour guide and continue to lead it as a part of WalkingTown DC. The tour involves about one and a half miles of walking and a number of staircases. It takes about three hours from start to finish.

The sites on the tour are unusual—places that most Washingtonians walk past without noticing. Most of them are covered within this book. They include:

- The Temperance Fountain, which kicks off the discussion about the origins of the temperance movement.
- The Patent Office (Seventh and F Streets, Northwest), which is now the Smithsonian American Art Museum and held Abraham Lincoln's second inaugural ball in 1865. Lincoln was a teetotaler. Poet Walt Whitman worked in the building at the time.
- Calvary Baptist Church, where the Anti-Saloon League had its first national convention in 1895.
- We then take the Metro (Red Line) to Dupont Circle and the Woodrow Wilson House. Wilson was president when prohibition began.
- The tour finishes at the Spanish Steps (S and Twenty-second Streets, Northwest), where we discuss how prohibition unraveled.

Afterward, many temperance tourists are thirsty, so we usually stop for a beer. There are plenty of places to choose around Dupont Circle.

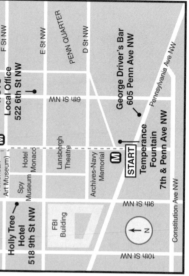

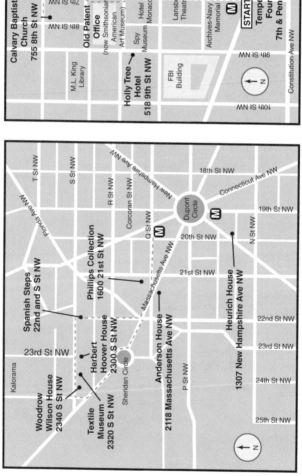

WASHINGTON, DC - TEMPERANCE TOUR

How to get to the start
Take the Metro (subway) Green/Yellow lines to Archives/Navy Memorial station.

Tour Route - - - -

Metro (Subway) Transfer
At Gallery Place, take the RED Line towards Shady Grove. Go 3 stops to Dupont Circle and leave by the north exit.

Map of the Temperance Tour. *Kenneth P. Allen, mapmaker.*

BIBLIOGRAPHY

Abernethy, Lloyd. "The Washington Race War of July, 1919." *Maryland Historical Magazine* (December 1963).

Afro-American. March 10, 1934.

———. "A Whole Crop of Human Lawlessness." February 23, 1929.

———. "D.C. Taxicabs Form Arteries Through Which Races Mix." September 24, 1932.

Albright, Robert C. "Bill Signed; Capital Gets Beer Tonight." *Washington Post*, April 6, 1933.

Allen, Frederick Lewis. *Only Yesterday: An Informal History of the 1920s.* New York: Perennial Classics, 2000.

Anderson, Larz, III. Journal, 1924. Society of the Cincinnati Library, Washington, D.C.

———. Journal, 1929. Society of the Cincinnati Library, Washington, D.C.

———. Journal, 1930. Society of the Cincinnati Library, Washington, D.C.

———. Journals, 1933–1936. Society of the Cincinnati Library, Washington, D.C.

Behr, Edward. *Prohibition: Thirteen Years that Changed America.* New York: Arcade, 1997.

Bicknell, Grace Vawter. *The Inhabited Alleys of Washington, D.C.* Washington, D.C.: Committee on Housing, Woman's Welfare Department, National Civic Federation, 1912.

Borchert, James. *Alley Life in Washington: Family, Community, Religion, and Folklife in the City, 1850–1970.* Chicago: University of Illinois Press, 1980.

Brown, George Rothwell. "Post-Scripts." *Washington Post*, January 25, 1927.

———. *Washington: A Not Too Serious History.* Baltimore, MD: Norman Publishing, 1930.

Burner, David. *Herbert Hoover: A Public Life*. New York: Knopf, 1979.

Cassiday, George L. "Cassiday, Capitol Bootlegger, Got First Rum Order From Dry." *Washington Post*, October 24, 1930.

————. "Cassiday Reveals Rum Dealings in U.S. Senate Office Building." *Washington Post*, October 27, 1930.

————. "Part of Cassiday's Rum Supply Stored in House Office Building." *Washington Post*, October 25, 1930.

————. "Rum Buyers in Capitol Indicted as Law Violators by Cassiday." *Washington Post*, October 29, 1930.

————. "20 to 25 Orders Daily Called Fair Capitol Trade by Cassiday." *Washington Post*, October 26, 1930.

Chase, Hal S. "'Shelling the Citadel of Race Prejudice': William Calvin Chase and the Washington 'Bee,' 1882–1921." *Records of the Columbia Historical Society of Washington, D.C. 1973–1974*. Baltimore, MD: Waverly Press, 1976.

Clapper, Raymond. "Happy Days." *American Mercury Reader*. Garden City, NY: Country Life Press, 1944.

Coffey, Thomas M. *The Long Thirst: Prohibition in America: 1920–1933*. New York: W.W. Norton, 1975.

Coolidge, Calvin. *The Autobiography of Calvin Coolidge*. New York: Cosmopolitan, 1929.

Daly, John J. "The Lost Legion." *Washington Post*, September 16, 1928.

Davenport, Walter. "Bartender's Guide to Washington." *Collier's*, February 16, 1929.

D.C. Alcoholic Beverage Control Board, 1934 Report.

Einstein, Izzy. *Prohibition Agent No. 1*. New York: Frederick A. Stokes Company, 1932.

Ellington, Duke. *Music Is My Mistress*. New York: Da Capo Press, 1973.

Evelyn, Douglas E., and Paul Dickson. *On this Spot: Pinpointing the Past in Washington, D.C.* Washington, D.C.: National Geographic, 1999.

Federal Writers' Project. "The Negro in Washington." *Washington: City and Capital*. Washington, D.C.: Government Printing Office, 1937.

Folliard, Edward T. "Happy Birthday, Volstead Act." *Washington Post*, January 11, 1970.

Gatewood, Willard B. *Aristocrats of Color: The Black Elite, 1880–1920*. Bloomington and Indianapolis: Indiana University Press, 1990.

Getty, Frank. "Bright Spots Go Gay With Legal Liquor." *Washington Post*, March 1, 1934.

Green, Constance McLaughlin. *The Secret City: A History of Race Relations in the Nation's Capital*. Princeton, NJ: Princeton University Press, 1969.

———. *Washington: Capital City 1879–1950*. Princeton, NJ: Princeton University Press, 1963.

Heurich, Christian. *From My Life: 1842–1934*. Trans. and ed. Eda Offutt, 1985. Washington, D.C.: privately published, 1934.

Hoover, Herbert. *The Memoirs of Herbert Hoover: The Cabinet and Presidency, 1920–1933*. New York: Macmillan, 1952.

Kelly, John. "Congress Winks at Prohibition in Bootlegger's Tale." *Washington Post*, April 27, 2009.

Kerr, K. Austin. *Organized for Prohibition: A New History of the Anti-Saloon League*. New Haven, CT: Yale University Press, 1985.

Kobler, John. *Ardent Spirits: The Rise and Fall of Prohibition*. New York: Da Capo Press, 1993.

Lewis, Sinclair. *Babbitt*. New York: Library of America, 1992.

Liggett, Walter W. "How Wet is Washington?" *Plain Talk*, December 1929.

Locke, Alain. *The New Negro*. New York: Arno Press, 1928.

Mencken, H.L. "Coolidge" (from *American Mercury*, April 1933). *The Vintage Mencken*. Comp. Alistair Cooke. New York: Vintage Books, 1990.

———. "The Cult of Hope." *Prejudices: A Selection*. Selected by James T. Farrell. Baltimore, MD: Johns Hopkins University Press, 1996.

———. "Days Are Done for, Mencken Says, and Is Sad at the Thought." *Baltimore Evening Sun*, June 15, 1932.

———. "Definition." *Prejudices: A Selection*. Selected by James T. Farrell. Baltimore, MD: Johns Hopkins University Press, 1996.

———. "The Eve of Armageddon." *Baltimore Evening Sun*, November 5, 1928.

———. "The Husbandman." *Prejudices: A Selection*. Selected by James T. Farrell. Baltimore, MD: Johns Hopkins University Press, 1996.

———. "Journalism in America." *Prejudices: A Selection*. Selected by James T. Farrell. Baltimore, MD: Johns Hopkins University Press, 1996.

———. "Little Red Ridinghood." *Baltimore Evening Sun*, December 29, 1930.

———. "Mencken Tells How Magic Word 'Beer' Brought the Cheers." *Baltimore Evening Sun*, October 26, 1932.

———. *My Life as Author and Editor*. Ed. Jonathan Yardley. New York: Knopf, 1993.

———. "The Noble Experiment (from *Heathen Days*, 1943). *The Vintage Mencken*. Comp. Alistair Cooke. New York: Vintage Books, 1990.

————. "On Government." *Prejudices: A Selection*. Selected by James T. Farrell. Baltimore, MD: Johns Hopkins University Press, 1996.

————. "Roosevelt: An Autopsy." *Prejudices: A Selection*. Selected by James T. Farrell. Baltimore, MD: Johns Hopkins University Press, 1996.

————. "Roosevelt." *Baltimore Evening Sun*, January 2, 1934.

Miller, Kelly. "Baptists Adjured to Go on Record for Prohibition." *Afro-American*, July 26, 1930.

————. "Dean Miller in Role of Altruist." *Afro-American*, February 27, 1932.

————. "Kelly Miller Says." *Afro-American*, June 15, 1923.

————. "Prohibition and Crime Wave Were Running Mates." *Washington Tribune*, December 14, 1933.

————. "Two Colored on Prohibitionists' Pay Roll," *Afro-American*, May 30, 1931.

Miller, Kristie. *Ellen and Edith: Woodrow Wilson's First Ladies*. Lawrence: University of Kansas Press, 2010.

Okrent, Daniel. *Last Call: The Rise and Fall of Prohibition*. New York: Scribner, 2010.

————. "Wayne B. Wheeler: The Man Who Turned Off the Taps." *Smithsonian*, May 2010.

Report of the Fifty-seventh Annual Convention of the District of Columbia Woman's Christian Temperance Union, October 20–21, 1931. D.C. Public Library, Washingtoniana Collection.

Rogers, J.A. "Jazz at Home." *The New Negro*. Ed. Alain Locke New York: Arno Press, 1928.

Rogers, Will. "Will Rogers Says Prohibition Works When You Drink It." *Washington Post*, January 22, 1927.

Rorabaugh, William J. *The Alcoholic Republic: An American Tradition*. New York: Oxford University Press, 1979.

Ruble, Blair A. *Washington's U Street: A Biography*. Washington, D.C.: Woodrow Wilson Center Press, 2010.

Rusk, Rufus S. "The Drinking Habit." *Annals of the American Academy of Political and Social Sciences* 163 (September 1932).

Standard Business Service. *Liquor Dealers, Washington, D.C.* Washington, D.C.: Standard Business Service, 1940.

U.S. Census 1920. Census.gov. http://www2.census.gov/prod2/statcomp/documents/1921-02.pdf.

Washington Bee. "Jim Crow Negroes." February 8, 1908.

————. Keystone Laboratory advertisement. November 1, 1917.

————. "The Rights of the Black Man." August 2, 1919.

————. "This Nation's Gratitude." July 26, 1919.

————. "Temperance Advocates." February 16, 1907.

————. "Temperance 'Jim Crow' Annex?" December 28, 1907.

————. "Temperance Shams." February 6, 1909.

Washington City Directory, 1917.

Washington Post. March 28, 1921.

————. "Beverage for Summer." July 26, 1891.

————. "Clubs Urge Repeal in Crusader's Poll." November 24, 1930.

————. "Data on Embassy Liquor is Refused." February 22, 1923.

————. "District is Termed Rum Dealers' Haven." February 10, 1932.

————. "Elaborate Place Nets 20 Pints in Liquor Raid." August 18, 1933.

————. "Famous Shoomaker's is Closed." March 17, 1918.

————. "55,876 Wet, 1,398 Dry in Washington Canvass." February 5, 1923.

————. "First to Sell Legal Liquor." March 1, 1934.

————. "Five Are Held Under Bond in Liquor Raid." February 18, 1934.

————. "Floating Bar Seized in Raid along Potomac." August 6, 1933.

————. "Glassman's Rent-a-Car Head Surrenders as Hunt Start." August 16, 1929.

————. "H.L. Mencken Hails Repeal, Raps Politicians and Clergy." December 6, 1933.

————. "Liquor Levy List First Drafted by Crusaders." December 12, 1933.

————. "'Man in the Green Hat' to Tell Capitol Hill Rum Secrets." October 23, 1930.

————. "No Dry America Until World is Dry, He Says." December 3, 1921.

————. "Nurses Acquitted by Court-Martial in Smuggling Case." June 18, 1925.

————. "Odd Names to Go With Obliteration of Alleys in D.C." October 23, 1934.

————. "Pinchot Demands Congress Inquire Why Dry Law Fails." January 17, 1924.

————. "Police Storm De Luxe Club, Seize Liquor." November 4, 1933.

————. "Prohibition Ranks Reported Split on Pinchot's Charges." January 18, 1924.

————. "Prohibition Revolt is Pictured by Lusk." August 14, 1932.

————. "Raiders Find Rum in 934 Places Here Within Seven-Month Period." October 12, 1930.

————. "Riots Elsewhere, Forecast by Negro." July 25, 1919.

————. "Senator Greene Hit By a Stray Bullet in Bootleg Battle." February 16, 1924.

———. "Southeast Citizens Charge Police Let Bootleg Tide Flow." January 13, 1926.

———. "Speakeasies' Boom Seen in New Orders." March 9, 1933.

———. "Speakeasy Raided by Ruse; 'Best People' List Seized." November 20, 1929.

———. "36 in Three Groups Indicted on Charges of Liquor Violation." April 1, 1924.

———. "Washington's 'Little Back Rooms.'" November 18, 1928.

———. "Wet and Dry Bodies Clash on Raid Data." February 14, 1932.

———. "Wild Downtown Auto Gun Battle and Pursuit End as Car Crashes." January 22, 1922.

Washington Star. "King Booze Quits Booze in Capital." November 1, 1917.

———. "Raid Gaslight Speak." March 4, 1925.

———. "Return of Legal Liquor is Quiet." March 1, 1934.

Washington Times. "Bars Go Dry in Eleventh Hour Rush of Thirsty Ones." October 31, 1917.

———. "Many Jobless if District Goes Dry." January 11, 1917.

———. "More Business With City Dry Says Sheppard." October 31, 1917.

———. "900 Saloon Porters of Capital Want Jobs." October 31, 1917.

———. "Those Departed Days." July 3, 1919.

Washington Tribune. "Protest Liquor at Luncheonette." March 1, 1934.

Wheeler, Charles V. *Life and Letters of Henry William Thomas, Mixologist.* Washington, D.C.: privately printed, 1926.

Wheeler, Wayne. Letter to the editor. *Washington Post*, November 22, 1925.

Willebrandt, Mabel Walker. *The Inside of Prohibition.* Indianapolis, IN: Bobbs-Merrill, 1929.

Wilson, Edith Bolling. *My Memoir.* Indianapolis, IN: Bobbs-Merrill, 1939.

INDEX

About the Author

G arrett Peck is a literary journalist and craft beer–drinking, wine-collecting, gin-loving, bourbon-sipping, *Simpsons*-quoting, early morning–rising history dork. He is the author of *The Prohibition Hangover: Alcohol in America from Demon Rum to Cult Cabernet* and leads the Temperance Tour of Prohibition-related sites in Washington, D.C. *Prohibition in Washington, D.C.: How Dry We Weren't* is his second book. A native Californian and Virginia Military Institute graduate, he lives in lovely Arlington, Virginia. His website can be found at www.garrettpeck.com.